A Bit of Earth in the
Somerset Hills

A Bit of Earth in the
Somerset Hills
Growing Up in a Small New Jersey Town

Gordon Thomas Ward

Charleston London

History
PRESS

Published by The History Press
Charleston, SC 29403
www.historypress.net

Originally published 2006
The History Press edition 2007

Manufactured in the United Kingdom

ISBN 978.1.59629.382.3

Library of Congress CIP data applied for.

Notice: The information in this book is true and complete to the best of our knowledge. It is offered without guarantee on the part of the author or The History Press. The author and The History Press disclaim all liability in connection with the use of this book.

Photographs and Illustrations
All photographs © 2006 by Gordon T. Ward unless otherwise noted. Credits for vintage photographs are unknown and were obtained through the author's private collection or the courtesy of the Bernardsville Public Library Local History Collection. The cover image is an original pastel by Linda Quinn entitled *Somersetin View*. The sketch of the Chauffeur's Apartment was obtained through the courtesy of William L. Feldmann and Burgdorff ERA Realtors. The map of the Somerset Inn Golf Course was found in a circa 1900 promotional pamphlet for the inn. The photograph of Francis G. Lloyd and his terriers is from *The Scottish Terrier*, Outing Publishing Company, 1915. The photograph of the author and bird was taken by Mildred Ward. The photograph of Mildred Ward and her cake was taken by an unknown photographer and has been acquired from the private collection of Mildred H. Ward. The cartoon illustration of the haunted trail was specially created for this book by Richard Feldmann, Copyright © 2006 W. Richard Feldmann. The photograph of The Maples and the photograph of the fountain statuary were taken by Helen Walton.

This collection of memories and historical anecdotes is dedicated to my parents, Warren and Mildred Ward, who encouraged me to dream, create and explore, and to my godparents, Bill and Betty Feldmann, who first sparked my love of history and stories from the past.

Contents

"Acre," a poem by Gordon Thomas Ward 9

Preface 11

Acknowledgements 13

1 An Invitation 15

2 Overview 19

3 A Tour 23

4 Places to Remember 55

5 Wild Inhabitants 89

6 Around the Seasons 107

7 Events and Pastimes 133

8 The Unexplained 161

9 The Residual Heart 185

About the Author 189

Acre

An acre of land to breathe upon
Surrounded by historic woods,
What stories are told in the whispering trees
As they sway
Back and forth,
Boreal metronomes
Animated by the wind?
Come hither and listen.
Our stories are many
Of long withered lives
And times long forgotten.

An acre of land alone in time,
How many feet have trod your soil?
The Lenape held sacred this ground,
Their mother, provider of provisions and shelter.
Her fibers contained the spirits of forefathers.
Many farmers followed with plows
To cut the brown, productive earth,
Preparing to sow.
Their cattle have grazed
Past barbed pasture wire,
Now swallowed by the trees and time,
So that the neglected, rusted metal
Now appears to grow
From the middle
Of the rough, expanding trunks
Like cinnamon whiskers.
The brook speaks in sparkling echoes
Of all the explorers who searched its banks
In rolled-up overalls
Searching for crayfish beneath the stones,
Abandoning boots their mothers had sent.

An acre of land to celebrate
The joys of life,
How many holidays have you seen?
Groves of Christmas trees must have graced
This unassuming residence
With carols, turkey, and pumpkin pie
And angels bending near.
The lawn embraced the family groups
Who gathered for games
On the Fourth of July

While fathers cooked dinners on open flames.
I fancied aromas still carried on the breeze.
I can almost hear the laughter of children
Who played in the yard
Until day turned to dusk,
And they were called to wash and bed,
Leaving the yard
To fireflies and wild nightsounds.
Innumerable pumpkins
Illuminated the porch,
Hollowed in haste
And carved with demonic faces,
Designed to dispel demons
And tempt ghostly figures
Carrying candy sacks
Under their shrouds.

An acre of land to call my own,
To manage as I please,
What evidence does it hold
Of previous proprietors
Who expressed their love and respect for the land
Through labor and sweat?
They, who once touched the stones upon which I walk,
Now claim eternal marking stones
In churchyards down the country road,
Which I touch in respectful remembrance.
We have sought the shade of the same trees
And taken shelter in this house
Through thunder and ice.
We have survived
All that nature has offered us,
Given all that we could give,
Endured our private trials and joys.

An acre of land
Is more than a measured lot of earth.

An acre of land upon my hands...
What will my signature be?

Preface

Literature has always been a great source of inspiration for me. And so it was that when I sat down to review, sort and arrange the information in this book—one that reveals glimpses into my own background—I felt it would be somehow incomplete if I did not pay tribute to the words of others that spoke to my soul and made me realize the glorious power of the written word. As a result, the chapter titles of this book are further defined and augmented by some of my favorite lines and phrases from beloved poetry and prose. I would also like to note that the title of this book, *A Bit of Earth*, was inspired by a line in *The Secret Garden* by Francis Hodgson Burnett, 1911.

<div align="right">

G.T.W.
Bedminster, New Jersey

</div>

Acknowledgements

I would be amiss if I did not acknowledge my children, Melina and Cory. My desire as a father to provide them with a firm grasp of their roots was a large part of the inspiration for this book. As part of the writing process, they have listened to stories, tramped with me through the woods and along local roads to take photographs, accompanied me on fact-finding missions both in the field and library files, and over the many years it has taken to complete this project, they have been the best companions I could ever wish to have. I love them immensely.

There are also special places in my heart for all of my companions who shared my childhood with me and played significant roles in creating the memories found on these pages. You are deserving of more gratitude than I could ever convey. In addition, I would like to express my deep appreciation to the supportive individuals who provided feedback, acted as sounding boards, created artwork and helped me to research events from the past and acquire facts and photographs. In alphabetical order, these people are: Erin Anderson, Mike Anderson, Valerie Barnes, Gretchen Bierschenk, Joseph Bonk and Noel Baxter, Christyann Brown, Matt Cavaluzzo, Ellen Chokola, Laura Cole, Jennifer Delaney, Bernice Dreesen, Carol Ekholm, Richard Feldmann, William L. and Betty Feldmann, Jack and Doris Hankinson, Jean Hill, Lily Hodge, John Kalvin, June Kalvin, Peter and Gina Kalvin, June Kennedy, Marion Kennedy, Nancy Knobloch, W. James Kurzenberger, Jane Leyhan, Rudolph and Lois Lucek, Robert Masson, LeRoy Mattson, Don McBride, Sid and Pat Moody, Ann Moore, Rachel Mullen, Jessica Orr, R. Gordon Perry, Jude M. Pfister, Janice Phelps, Barbara and Philip Pitney, Joni Rowe, Arthur and Beatrice Snyder, Arthur Snyder III, James and Judy Spiniello, Louis Starr, Steve and Janine Sullivan, Maud Thiebaud, W. Barry Thomson, Cecil Veroom, Mary Lee Waldron, David and Helen Walton, George Ward, Mildred Ward and Gretchen Wilcox. Without the assistance, patience, inspiration and input from these people, this labor of love would not have been as complete.

1

An Invitation

I dwell in a lonely house I know
That vanished many a summer ago,
And left no trace but the cellar walls,
And a cellar in which the daylight falls,
And the purple-stemmed wild raspberries grow.

—Robert Frost, "Ghost House," from *A Boy's Will*

This is a love story, one of both time and place. The tales discussed on these pages revolve around the years 1959 to 1983 and a location known to some as Somersetin in Bernardsville, New Jersey. In the time that has passed since my childhood in this area, I have come to realize how much life for children has changed. The pressures and pace of today's world have had their effect, so much so that the experiences my peers and I had as children are now scarce and dwindling commodities. Children need the unstructured time and space in their lives to explore, to investigate, to pretend and observe, to wallow in nature, and I wonder, in time, what the current and future generations of children will have to say about their connections with the land and their personal experiences with the natural world, its history and its stories.

In a sense, this book is a celebration of the geography of my childhood and others like it, but the appreciation of this place stretches beyond the years I have mentioned. While growing up, it became apparent to me that the world around my childhood home was charged with a rich, almost palpable history that pulsated and beckoned to be rediscovered. My appreciation for the area goes beyond nostalgia, and recognizes that the events in which I took part were but a link, a blip, in the chain of events that occurred on these grounds.

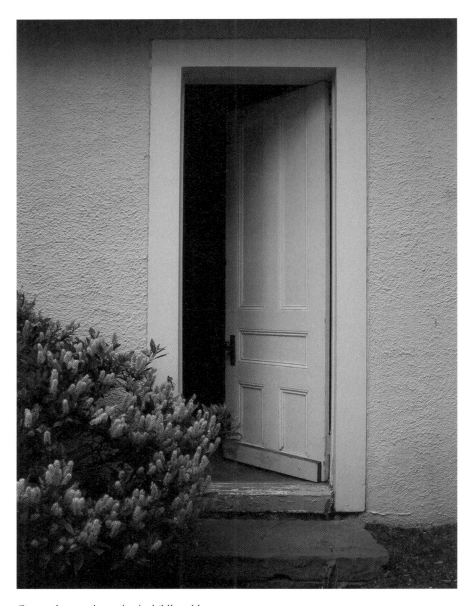

Garage door at the author's childhood home.

An Invitation

Our land has a story to tell to those who take the time to listen and learn. In today's transient world, there seem to be less and less people who feel any connection with, or have much knowledge about, the land where they live. Blame it on career transfers, urban sprawl, the pace of our society, neighborhood revitalization, increased auditory and visual stimuli that compete for our attention, or any number of other factors. The fact remains that more and more of us don't have a clue about the events that once occurred right under our own feet. It is, I believe, time to reverse this trend, for tradition and historical character help to shape who we are and provide us with roots.

In a very tangible manner, I am offering up my research and memories as a template map for a treasure hunt; a remarkable search for your own precious sense of place that will solidify, enrich and define your personal bonds with history and location. One might begin researching at a library, thumbing through local history books and old maps, photographs and newspapers. Tax maps and deeds are also a great way to track the names of current and previous landowners. Another option is to strike up conversations with the more established residents of a particular area. This may also prompt individuals to view themselves as authorities and sources of information about the areas where they were children and record what they experienced. All of these methods and activities will help to enrich not only your life but also the lives of countless others.

Developing categories for research will help in the collection of stories and information. As you can see from the chapter titles of this book, it is important to investigate a very broad range of topics in order to capture the full flavor of an area. These topics should incorporate contributions and influences from folklore, history and personal experiences, along with memories pertaining to the environment, specific activities, sites and locations. Define the parameters of your area, and then set out to observe, describe and record. Use your eyes: look for physical clues in the landscape such as old walls, foundations, or remains of fencing. Use your ears: hear and record the stories of others. Use your voice, computer and pen: share what you know, remembering that you don't have to be a professional writer to chronicle your story. But don't overlook or disregard your intuition, that sixth sense, the impressions you get from different areas. Humans have let this sense dull over time, but it is this ability to feel, to transcend time and place yourself in others' shoes and relate to what might have been felt by those who came before you, that makes history come alive! With this ingredient the past can be felt with the heart as well as known by the mind, and if we can begin to feel more in touch with our past, we will create a foundation from which we can address the future with increased vitality and strength.

I believe there is a memory—a kind of energy, if you will—that is stored in all places, that connects us with the past, helps us to create our memories and provides a palette for future generations to use as they paint the stories of their lives. I call this energy residual time, and it can be found at every location on this earth. It is a reflective sense of reverence for one's surroundings. It's a connectedness to the land and the people who have come and gone before us. It is the aura in the atmosphere that gives each area its unique "feel." It is a cornucopia filled with different personalities, cultures, folklore, stories and events; the essence of history is laid flat out at our feet and available to anyone who has the time, sensitivity and energy to learn, feel and look just under the surface of their day-to-day lives. As Walt Whitman stated in his poem "Kosmos": "Who, constructing the house of himself or herself, not for a day but for all time, sees races, eras, dates, generations, / The past, the future, dwelling there, like space, inseparable together."

On many levels the search for an area's unique story can be a very enlightening experience, and it doesn't really matter where you find yourself living. Apartment dwellers, farmers, suburban families, urbanites and owners of large estates all have similar journeys that lie before them, for none of us will find ourselves the first human being living in a particular place. There are always stories to learn about the geography around you. They help to shape its character, and they can add a magnificent sense of wonder to a place you may consider to be yours.

Herein lays the ultimate purpose for this book. With people being transferred, caught in the current of the mobile workforce and surrounded by mounting levels of distractions and sensory white noise, it becomes easy to overlook local and personal history. However, the truth is we are all forging links of existence in the places we live. All of these links are historic; they all capture slices of life influenced by the past and pointing toward the future; they make us unique. We all consume, create and cultivate in the same breath, and we owe it to ourselves and those who follow us to preserve our stories, hold on to them and pass them on to others. They are, in the end, our only real link with the past.

The names of people and locations in this book are specific to a handful of lives, but the genres of events will be familiar to many, and the opportunity for similar exploration and discovery is available to all. Every one of us matters. Every one of us has a unique perspective on the local milieu, and every one of us is an invaluable building block in our immense cobblestone road of history. So consider this to be an invitation—an invitation to share my thoughts and experiences, and in doing so, begin to explore your special bond to the land and the residual time around you, wherever you may be.

2

Overview

*Whether I shall turn out to be the hero of my own life, or whether that
station will be held by anybody else, these pages must show.*

—Charles Dickens, *David Copperfield*

My childhood in Somersetin was a magical time and place to do the
business of growing up. Serenity and security hung thick in the air, and
the surrounding woods, fields, streams and back yards beckoned with
the promise of unending exploration, mysterious hiding places, treetop
lookouts, an abundance of wildlife and relics from bygone times. These
were the tools of the trade for a child's imagination, and my friends and I
were masters of our craft.

There was a bountiful amount of space in which to perpetrate our daily,
childhood explorations. This was a time when fences seemed not to exist
and property lines were blurred, marked only by hedges, trees, or gravel
driveways. Nestled in the northeast corner of Somerset County, New
Jersey, this bit of earth known as Somersetin is part of the Borough of
Bernardsville, which is named after Francis Bernard, the royal governor of
New Jersey from 1758–1760. The town used to be called Vealtown until
1840, and both Vealtown and Bernardsville were actually subsections of
neighboring Bernards Township until the spring of 1924. Somersetin is
bordered on the north by Washington Corner Road, Hardscrabble Road on
the east (so named because the early inhabitants of this road had a difficult
time eking out a living in this hilly and rocky area), Lloyd Road on the south,
and has Mendham Road marking the most western side of the parcel. A
hilly area offering a mixture of deciduous woods, ponds, streams, fields and
yards, the air had a clean, crisp quality, which my Great Aunt Ella from New
York City used to compare to the smell of freshly sliced watermelons.

Eastern corner of Somersetin.

Each season had its distinct and definite grasp on the region. Winters were bitter cold with a perpetual snow cover that seemed to always reach up to frost the windows of our home. Spring dripped with the scent of forsythia and lilac in a world awash in that new golden-green hue of emerging growth. Summers, painted in goldenrod, Queen Anne's Lace, phlox, milkweed and a spectrum of butterflies, were hot and humid and made the local brooks and streams even more inviting. Late summer thunderstorms heralded the coming of autumn, which promised the brightest red, orange and yellow leaves I can remember, and chased everyone inside on chilly evenings, the smell of burning leaves still lingering in the air. Oak, maple and poplar trees towered above us, and a plethora of magical places lay at our feet amidst the nooks and crannies of our neighborhood.

Neighbors were friends—people you saw every day in their yards and who waved and shouted hello when you passed. Telephone callers always seemed to be people you knew. As a child, one felt safe, protected and free to explore and observe everything, and that is exactly what I did. Within the fabric of our neighborhood, my friends and I moved freely in and out of yards, across fields, through woods and down wooded lanes, immersed in life and soaking up every new and precious moment we could. And

when darkness fell and we found ourselves in bed, we nodded off under our blankets with the satisfaction of our daily adventures spinning in our heads, the lullabies of the night creatures and soft breezes reaching our ears through open windows, and the anticipation of continuing our seemingly endless saga held fast in our hearts.

3

A Tour

Memories may escape the action of the will, may sleep a long time, but when stirred by the right influence, though that influence be light as a shadow, they flash into full stature and life with everything in place.

—John Muir, *A Thousand-Mile Walk to the Gulf*

The walls and grounds that embrace us as we live out our lives tend to become viewed as sanctuaries of a sort. They hold our fondest memories and shelter us from the outside world. Growing up in an older home and a historic area meant that my experiences were building upon past events and were extending the emotional and physical history of the location. This was the thought that most captured my imagination as a boy; the thought that adults somewhere carried memories of themselves as children in the same places I knew as a child. Holidays, family events and countless conversations regarding everything from the weather to national crises have all played themselves out inside the home of my childhood, and it was fun to think about what life must have been like on the former Francis G. Lloyd Estate, a part of which would eventually become my parents' home.

Some of the information that I have as fact was gradually assimilated over the twenty-four years I spent living in the Lloyd Road house. Indeed, a good deal of the information I have about the old estate comes from the writing of Norman Hankinson whose father was the kennel master for the Lloyds. Mostly, though, my thoughts of the past served to bolster my feelings of respect for the houses, the previous residents and the land on which they existed. I made my own memories, knowing that my turn would come to hand them off to someone else with the house and the land acting as consistent witnesses to history.

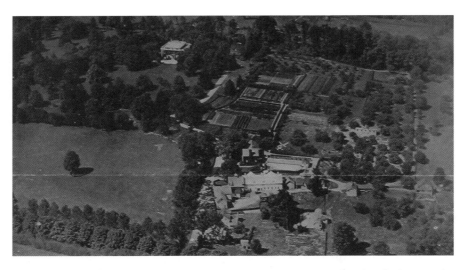

Vintage photograph of the Lloyd Estate. The kennelman's cottage is located in the lower and far right section of the photo.

Walking through History

The Lloyd Estate consisted of a collection of large and small dwellings for both man and beast, coexisting among a variety of environments on eighty-one acres of land. The remembrances that I will relate to you will be more vivid in your mind's eye if I first provide you with a short, descriptive tour of the area and the majority of its homes that are pertinent to my tenure and experiences. This, in conjunction with the map, will help you imagine the layout of the property. Since my boyhood home sits near to the geographic center of the former estate, I will begin the descriptive tour from there.

My house used to be the home of the estate's kennel manager, Herbert "Bert" Hankinson, who looked after Mr. Lloyd's world-class Scottish Terriers. Having come to America from England in 1914, the famed kennel man was hired by Mr. Lloyd in 1916 and moved in with his wife, Gertrude, their nine-year-old daughter, Edna, and six-year-old son, Norman. Very soon after settling into his new position, Bert's wife gave birth to their second son, Jack. He was born in the house and delivered by a doctor who made his way from Mendham, the town just north of Bernardsville, in a horse and buggy. Jack has told me that he has the original bill from his birth, which records that the doctor charged ten dollars for his medical services. The Hankinson family lived in the house for a little over four years.

On October 7, 1920, Bert Hankinson and Francis G. Lloyd took the same early morning train into New York City. The two men were not riding in

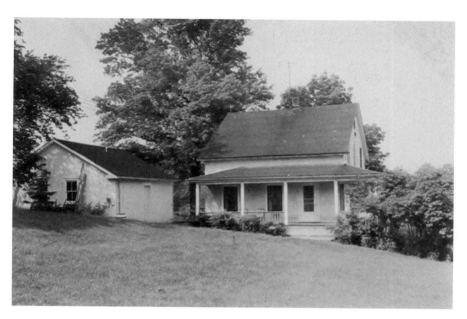

The author's former home as it appeared in 1958.

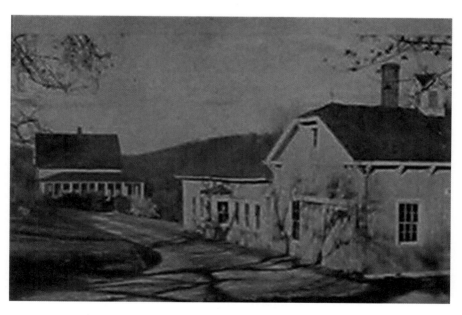

Vintage estate photograph looking northeast toward the kennelman's cottage.

the same car, as Mr. Lloyd traveled in a club car. Somewhere in the Hudson Tubes between Ninth and Fourteenth Streets, Mr. Lloyd suddenly died. Ironically, Bert Hankinson did not get the news until he retuned home from New York later that day and was summoned to what the estate's employees called the Big House. Shocked and saddened by the news, Bert was also instructed to get rid of all the Scottish Terriers and given two weeks to move his family off the estate. I think it is safe to say that Mrs. Lloyd did not have the same affection for breeding and showing Scottish Terriers as Francis G. Lloyd. By early 1921 Bert had moved his family to Basking Ridge and established his own champion producing kennel called Scotshome.

Another famous owner of my childhood home was the race car driver Walter E. Hansgen. Mr. Hansgen was a World War II veteran who took up racing in 1950. He made quite a name for himself, and in 1957 he was named "Sports Car Driver of the Year" by *Sports Illustrated* magazine. My parents, moving from Tacoma, Washington, when I was eleven months old, bought our house from the Hansgens in 1959, and Mr. Hansgen moved his wife and two children to Bedminster. On April 7, 1966, Walter Hansgen died tragically at the age of forty-six as a result of injuries he suffered five days earlier in a rainy, trial run at Le Mans, France. He is buried in the New Germantown Cemetery in Oldwick, New Jersey.

Renovations and modifications have since taken place at my childhood home to the point where it now stands at more than twice the size it was when I lived within its walls. The front door that I remember is now used as a back door, the layout being changed to establish a better orientation with the driveway. However, the original road used to come in from the opposite side of the house during the estate years, so the original configuration once made sense. Originally a two-story clapboard house, it was white stucco during my tenure and is now yellow. What I remember is the front door faced in a southwesterly direction toward Mendham Road and looked out across a spacious yard surrounded by trees and wooded areas. Several of the Lloyds' summer kennels and a Top Kennel for dogs used to occupy this area, but are no longer in existence. These kennels were once the working domain of Jimmy, the kennel assistant, who helped to feed and exercise the dogs, change the wood shavings used for bedding and prepare the animals for shows.

A wooden porch led off to the left of the door to a two-car garage, separated from the house by a flagstone breezeway. Rounding the corner to the right set one on the gravel driveway that overlooked another yard and a patio constructed of the same hefty flagstone as the breezeway.

Our driveway led northeast down the hill, but the fork at the top of the hill led west and up to another home past the site of the former chicken

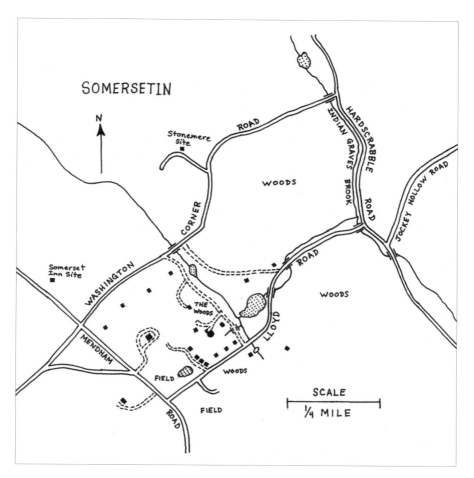

Map of Somersetin. The author's former home is indicated by the solid, circular dot.

runs, and beyond this lay a wooded area to the east and north. At one time, a wagon road called the Back Road passed through here and led past a water tower on the way up to the Big House. As I remember it, if one were to blaze a trail to the west of the former chicken runs, it would lead up and through a tall metal fence and past the remains of the Lloyd gardens. These gardens, along with the surrounding grounds, were originally designed for the home's former owner George I. Seney by Frederick Law Olmsted, acknowledged as being the founder of American landscape architecture and famous for designing, among other accomplishments, Central Park in New York City.

Eventually the gardens spilled into an expansive lawn area that continued all the way to Mendham Road, surrounding a fountain, lily pools and the Big House, once the residence of Francis G. Lloyd. Mr. Lloyd was only

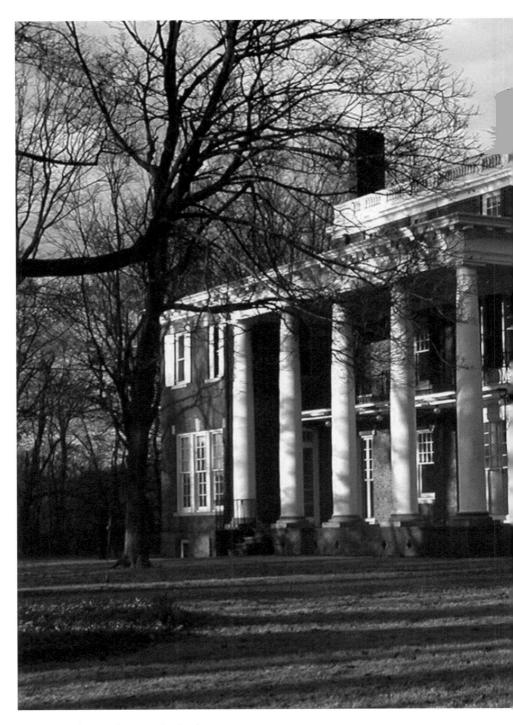

The Maples, home of Francis G. Lloyd.

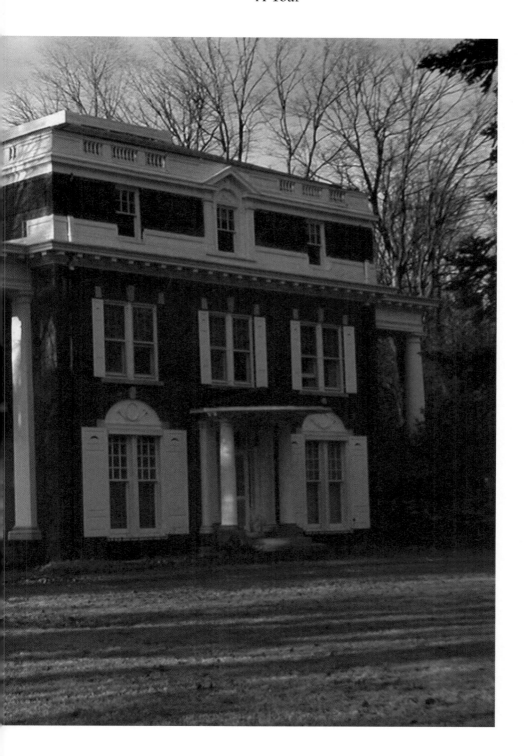

one of the many wealthy men to own estates in the Mountain Colony, a collection of estates in this area of Bernardsville that flourished from the late 1890s to the mid 1920s. Before that, the area was known in 1850 as Bankers Mountain. Mr. Lloyd was the president of Brooks Brothers, having advanced all the way up the company ladder from a position as an office boy making eighteen dollars a month. The wealth that he eventually acquired allowed him to build a large, twenty-three-room Georgian home that was named The Maples. However, the Lloyds were restrained and not as pretentious as some of the other residents on the Bernardsville Mountain, and the family came to typify the genteel grace that epitomized life in the Mountain Colony.

The stature of the Lloyds' house was impressive and must have been imposing to the employees of the estate, but it appears to have had an interesting beginning and gone through quite a metamorphosis. The house was originally a large, red brick home built from 1796 through 1797 by Francis Peppard Jr., whose father had come to America in 1742 at the age of seventeen and was a Presbyterian preacher. After thirty-six-year-old Francis Peppard Jr. married nineteen-year-old Catherine Savidge on September 15, 1796, the newlyweds moved into their new home the following year. According to historical documents, the home was soon surrounded by a carriage house, barns and several cottages for the hired help. As this house was located on the same site as the Lloyds' estate house would be ninety-seven years later, and no record exists of it being demolished, it is thought to have become the center section of The Maples.

When Francis Peppard Jr. died on February 13, 1840, his son Reuben Clark Peppard took over his father's estate. R.C. Peppard had recently married Catherine Van Ness, and the couple raised a fourth generation of the Peppard family in the brick home, a fact verified by an 1850 map of the area that shows the home of R.C. Peppard standing on this site. On December 4, 1862, R.C. Peppard passed away, and Catherine remained on the estate with her children until 1869, having sold the house and fifty-five acres to Francis Oliver during this time.

Catherine Peppard also sold some other land to George Ingraham Seney, a prominent, wealthy, New York banker and philanthropist who came to the area in the early 1860s. George I. Seney went on to purchase the former Peppard home and its land from Francis Oliver around 1863 and made modifications to the house employing Victorian style architecture using wood and brick. At one point he owned approximately 1,400 acres of land on both sides of Mendham Road, including the area between what is now Lloyd Road (originally called Seney Farm Road) and Washington Corner Road, before selling tracts of it to other incoming, prominent families

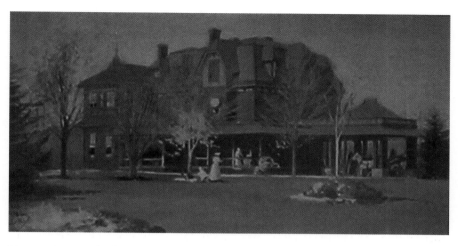

Vintage photograph of the home of George Ingraham Seney.

wishing to establish residences in the area. Using his Bernardsville estate largely as a vacation home, Mr. Seney, former president of the Metropolitan Bank of New York, is the man credited with giving the Mountain Colony its start. In fact, after Seney died on the evening of April 8, 1893 at the Grand Hotel in New York City, he was important enough for the *New York Times* to print his obituary on the front page.

Enter Francis G. Lloyd, who modified and built around the existing house, having purchased it after Seney's death in 1893, and added columns to create the huge, Georgian-style estate that stood on this site until 2004. In order to allow light to penetrate the basement level, some of the doors in the basement led into small, open, flagstone-floored rooms that resembled outdoor patios. Outside, a bowling green still dominates the front lawn of this property—one that must have been witness to many society gatherings during the estate's golden years. In fact, the bowling green was built to entertain Edward, the twentieth Prince of Wales, who stayed with the Lloyds for about one month. At one point in time a gazebo stood on the northern corner of the bowling green, offering an exceptional view of the competition and the surrounding property.

Inside the home were enormous copper tanks, installed in the attic, to hold the water supply for the house. I also remember seeing the original voice tubes that were used for communication between the Lloyd family members and their seldom seen help in the Big House. Among others who worked inside and outside of the Big House during the estate era were Bridget (the cook), Beasey (the waitress and stern majordomo), Margaret (the lady's maid) and Joe (the houseman).

The Lloyd family spent a good deal of the winter months in Manhattan. During the summers, the Lloyds would spend time at their summer house in Quogue, Long Island. Apparently the family would travel by train, bringing with them their own dairy cow. Mrs. Lloyd also liked music and had a pipe organ on the first floor. During Christmas celebrations she would play it for carol sings while people gathered outside the main entrance on the south lawn.

Remnants of the former estate can still shed light on the home's previous owners. For example, it seems as though Mr. Seney may have had some pull with the city of New York, for a sewer cover, located in the back lawn and installed during his residence, was cast and imprinted with the city's name. Another story revolves around a crack in the rear wall of the garage behind the Big House. Rumor has it that someone once hit the wall with one of the Lloyds' large automobiles, and the crack was never repaired. The home weathered many storms and events over the years, passing through the hands of the Manning family and finally the Mattson family. As former residents, the Mattson family tells the tale of a tornado that ripped through the property in the mid–1970s, taking down twenty-nine trees. According to Mr. Mattson, lumber mill workers removed the trees, including one pine tree that weighed ten tons!

Across from the south lawn of the Big House and past a sundial are the remains of a gravel drive that leads down toward Lloyd Road and past several other structures that now serve as single-family homes. On the southwestern side of this drive and past a row of pine trees were the field and the pond, which once supported the herd of milk and beef cows that the Lloyds kept. Cows were still being raised on this field when I was a boy, and were owned by the Rankin family.

At that time, Mr. and Mrs. Rankin lived in the first house at the top of this gravel drive, which we always called the "Right-of-Way." This lovely brick building, once named the Brick Cottage during the estate years, was partially covered with ivy when I was young and still has a protective front porch and windows with leaded, diamond-shaped windowpanes. Originally constructed in 1912 for Mr. Lloyd's daughter, it instead housed Silas, the estate's foreman, and is understandably much more spacious and elegant than the other homes on the grounds. Inside the attic of this house is a copper water tank, similar to the ones that were in The Maples. The Brick Cottage also had a generator, housed in its own room in the basement, which once provided electricity to the other cottages on the estate where the luxury of electricity must have been a welcome addition.

Mr. Rankin was a gifted physicist who worked for the Bakelite Corporation that made an early type of plastic. Earlier he had worked on the Manhattan

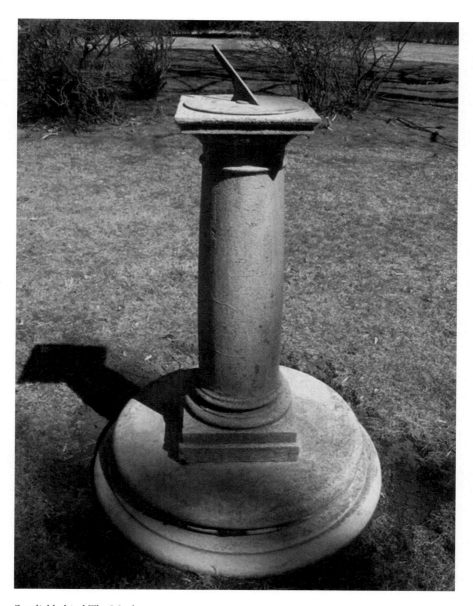

Sundial behind The Maples.

Project, the name given to the endeavor by the United States, working with the United Kingdom, Canada, and some European physicists, to develop the first nuclear weapons from 1942–1946. Employing over 130,000 people and including the work of noted physicists Albert Einstein, Leo Szilard and Robert Oppenheimer, the Manhattan Project eventually developed and detonated three nuclear weapons, all in 1945, including the Trinity test detonation on July 16 in New Mexico, and the two infamous bombs dropped over Japan. The first was "Little Boy," an enriched uranium bomb detonated on August 6 over Hiroshima, Japan, and the second was a plutonium bomb called "Fat Man," which destroyed Nagasaki, Japan, on August 9. After the devastating effects of the blasts were realized, the physicists shared a common view that the use of nuclear arms was a mistake and should never again be used in warfare.

Mr. Rankin also operated an "HAM" (amateur) short wave radio at his home, and I remember the equipment being set up in his living room and a large antenna attached to the side of his home. He found great enjoyment in operating the radio. In fact, it is said that he was even able to contact Antarctica at one point, which is very difficult to do. As Antarctica is halfway around the world, it was explained that this was accomplished by skipping the radio waves off of the ionosphere, an upper level of our atmosphere. This is a difficult maneuver at best!

In front of the Brick Cottage were the pump house and a summerhouse, which was built over a cistern. The pump house served several of the buildings on the Lloyd Estate and continued to supply the houses with water when I lived there until the well went dry in the mid–1960s. My godfather and former neighbor Bill Feldmann used to take it upon himself to maintain and fix the pump in all weather, day or night, whenever it would need repair.

Behind the Rankin house stood a greenhouse, cold frames and chicken coops. In this area was the place where Old Alec, the Lloyds' carpenter, once had a shop. These buildings were accessed by a road that used to lead below the Brick Cottage, past these structures, and continue on to the kennels and the kennel manager's home. Along this road used to stand a wagon shed, a two-story ice house, a stable for the estate's retired coach horses and a cow barn.

Continuing down the "Right-of-Way" brings one past three more two-story structures, all of which are now single-family homes and all on the northeastern side of the dirt road. The first was the former milk house and the stable for the work teams. There used to be a small, simple apartment above this stable occupied by a Hungarian farmhand named Cow Johnny and his wife, Helen. I imagine Cow Johnny must have had to keep early hours in his efforts to care for the Lloyds' livestock of cows, pigs and chickens. His

Summerhouse across from the Brick Cottage.

jobs must have included feeding and watering, milking, providing fresh hay and turning the cows out to pasture.

The Nibur family first occupied this home when I was young until Barbara Long purchased the property in the spring of 1970. Barbara and her husband, Philip Pitney, continue to reside here, beautifully maintaining the house much as it appeared when I lived in the area. A source of pride for both of them is the old milk house that includes decorative tiles on the interior wall from the Moravian Pottery and Tile Works, which was founded in 1912 by Henry Chapman Mercer, a Renaissance man of the early twentieth century. An archaeologist, historian, collector and ceramist, Mercer was born and died in Doylestown, Pennsylvania, and his hand-crafted tiles established him as a leader of the Arts and Crafts movement of the early 1900s. Mercer went on to produce tiles that adorn buildings throughout the United States and the world, including the rotunda and halls of the Pennsylvania State Capitol. The Lloyds, no doubt, wanted to incorporate this artist's work into their estate, and it is a beautiful addition. However, when the Niburs had moved in, the property needed attention. The tall grass in the expansive back yard was too much to handle, and as he did not have the heavy machinery necessary to cut the grass, sheep were brought in to eat it. Apparently they did an excellent job.

Former milk house.

Former stable and farmhand apartment.

Another interesting story concerns Mr. Nibur, who was a pilot for United Airlines. As he was approaching retirement, his family planned a party to celebrate his last flight. Two days before retiring and during his final flight, Mr. Nibur was hijacked to Cuba. Well, needless to say, he never showed up for his party that night. Not to worry, however. Mr. Nibur made it back about a week later, safe and sound, having returned to the United States and completed all the official paperwork and interviews that accompany such an event. As one might imagine, an even larger party was had at that point.

The next building used to be a three-car garage and chauffeur's apartment, which was once occupied by the chauffeur, Chester Wilder, and his wife, Hannah. When I was growing up, this is where my godparents, Bill and Betty Feldmann, lived along with their children, Richard, Gretchen and Christyann. Inside the former garage once stood the Lloyds' Locomobile, Rickenbacker and Cadillac station wagon. Maintenance on the vehicles would have been performed by Chester and Danny, the groom and under chauffeur. Danny McCarthy was the man who drove for Bert Hankinson, taking him and the dogs to shows. Besides transporting the Lloyds, the Cadillac was once fitted with curtains and used as an ambulance during the early twentieth century influenza epidemic. When this building was sold as a single-family home, some of the garage space was converted into living

Moravian tiles in the milk house.

space with a living room in the front and a sunken dining room with parquet wood flooring in the rear. Interestingly, this home continued to be heated as late as the 1960s by burning anthracite coal. A truck used to make deliveries and deposit the coal through a basement window on the northwest side of the house.

At the end of the "Right-of-Way" is the third and last building, which was first known to me as the Knobloch's, and later the Johnson's house. It was once the gardener's cottage complete with a stone smokehouse that stood in the backyard. The gardener and chief groundskeeper during the estate years was a man with the last name of Horsburgh. His son Tommy was friends with Jack Hankinson, the kennelmaster's son. With the acres of finely designed gardens behind the Big House, and four or five assistant gardeners to manage, I'm sure Mr. Horsburgh's position was a large responsibility. The fruits of his labor would have been one of the more visible as well.

When I was a child, both the Feldmann and the Johnson families had gardens in their back yards. The Johnsons had a beautiful vegetable, flower and herb garden, complete with catnip, which amused the Feldmanns' cats to no end. Many of the herbs and flowers were hung upside down to dry inside the Johnsons' kitchen, similar to a scene one might expect to find in historic Williamsburg. The Feldmanns, on the other hand, had a productive vegetable garden, and tilling the ground often turned up interesting items such as rusted horseshoes and other similar treasures that testified to the former use of the land.

Behind these last two houses, the chauffeur's garage and the gardener's cottage, is the place where the Bottom Kennel and the estate's pigpens used to stand. Aside from a very low cement wall, there are no longer any physical reminders of these previous structures.

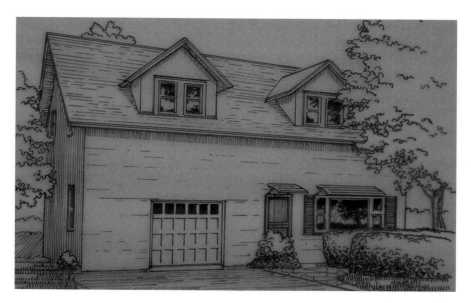

Former garage and chauffeur's apartment.

Reaching the end of the "Right-of-Way" puts one on Lloyd Road just below the first pond. Turning left down Lloyd Road takes a traveler past three homes on the left, which were not originally part of the estate. The first of these was the home of the Packard family, whose back yard offered the best sledding in the area. The second house sits on property once occupied by a white ranch house that was home to the Kalvin family. Steve Kalvin built the house himself, worked for a local construction company, and reportedly had the interesting ability to locate underground water and pipes in a very accurate manner by using divining rods. Coincidently, Steve's mother, Susan Kalvin, a woman of Hungarian descent, once worked on the Pyne Estate as a housemaid during the era of the Mountain Colony. If Susan could have gazed into a crystal ball at the time and been able to glimpse the future, I'm willing to bet that she would have been pleasantly surprised to learn that her own son would one day come to own part of a neighboring estate's land and build his own house on it.

Beyond the Kalvin site, there is only one more house to pass until arriving at my former driveway. This unpaved, gravel drive that leads up to my former home is about 300 yards in length and used to lead to two other homes as well. For most of my childhood years this road was known as Gordon's Lane, being named after me by my parents. Beginning on the northwestern side of Lloyd Road it dips down a small hill and travels through woods, over a stream that used to form a small pool on the left

before passing under the lane and in front of the former site of a small ranch house, also on the left. This house has since been torn down and the land naturally landscaped. Continuing up the drive, it rounds a sharp bend to the left, turning away from the remains of a dirt road that used to lead straight into a wooded area, and heads up another hill among mature trees where it eventually forms a "Y." The left fork leads back up to my former home where we began our journey.

This dirt and gravel lane was not the major access road for my house when it was part of the estate. At that time there was a road that accessed the back side of our garage and headed away in the opposite direction from the current driveway. Nevertheless, what we called Gordon's Lane had always existed as a secondary access/wagon road that wound down and through a once thriving apple orchard. Indeed, during my residence some of the apple trees still remained as gnarled reminders of the former stand of fruit trees.

The dirt road that once led straight ahead into the wooded area at the ninety degree bend in Gordon's Lane was known to me as Gary's Lane and was similarly named by my parents after my younger brother. This road originally existed as another wagon road on the Lloyd Estate and led to the estate's gravel pit. During the time I lived at Somersetin, Gary's Lane tracked through the dense trees to another gravel driveway that ultimately led to Washington Corner Road. This was the route I took to catch the school bus when I was in elementary school. It was a beautiful, shaded walk that overlooked a stream and passed very near to a pond on the right-hand side and not far from Washington Corner Road. The remains of the estate's gravel pit were also on this route and surrounded by an open field.

Once, on a very cold, winter's morning, I can remember missing the bus. I panicked, and was so afraid to go back home that I decided to retrace my steps along Gary's Lane to its intersection with Gordon's Lane and sit in a snow bank behind an old, black car that used to be perpetually parked at this point. I cannot remember the reason for my reluctance to go home, but I remained sitting in the snow for a good hour or so until I was shivering uncontrollably. Ultimately deciding to head home, I grabbed my school bag and headed up the hill. My mother, assuming me to be in school, was quite stunned to see me appear at the door, but she welcomed me with a warm bath that felt wonderful and did the trick of relieving the shivering.

Surrounding Roads

Many people regard roads and byways as only arteries of travel—a means of moving from place to place. But the roads surrounding Somersetin were

marvelous entities in and of themselves, and they provided many, many opportunities for investigation and activities for our inquisitive, imaginative minds and energetic bodies. Just as we should view ourselves as cobblestones in the road of history, our roads are foundational building blocks that delineate our sense of place.

As mentioned, Lloyd Road itself used to be called Seney Farm Road after George I. Seney until being named for Francis G. Lloyd, owner of the large estate that occupied much of this area in the early 1900s. Heading east on Lloyd Road, one travels past a large pasture on the left and down a hill that was more than once the place where I skinned my knees after running and stumbling in my haste to return from school. This hill leads past a pond and a gravel right-of-way for the four "cottages," also on the left that used to be part of the Lloyd Estate. Lloyd Road then continues past another gravel drive, which heads to my former home, around a bend to the left, down a second hill, with a second pond on the left-hand side, and across three small stone bridges in a wooded valley.

A map of 1850 tells us that a small schoolhouse used to stand on the northwestern side of the road, about seventy yards above the first curve and the second hill heading east, and very near to the site of the former Kalvin house. It was known as the Mount Vernon School, and it began in 1844 when its trustee, Mr. Thomas Nutt, received $22.53 as the share of the fund for this school. Mr. Nutt lived on Nutt Road, which is now named Washington Corner Road. The Mount Vernon School's first schoolmaster was Mr. John Y. Marsh, and there is an interesting story that accompanies him. It seems that Mr. Marsh lived in New York City as a young man, and while living there he had rescued a man from drowning. The man, wanting to express his gratefulness, paid the entire cost of John's education to become a minister. Poor eyesight forced John to abandon his religious training, however, and he came to the area to be a schoolmaster for this tiny, northernmost schoolhouse in what was then called Bernards Township. Very soon after arriving, John fell in love with and married a girl from the local Sanders (also spelled Saunders on some records) family, whose historic, pre-Revolutionary War era home is still located on Chestnut Avenue near the Hardscrabble Road intersection. The couple went on to live nearby in a small log cabin. Just when the Mount Vernon School, this little jewel of education, was dismantled is unknown, but it surely served the families living in the Hardscrabble area before the Civil War.

Today, the Snyder family lives in a house with its own very unique history, located directly across the street from the Mount Vernon School site and former Kalvin home. This property had been a working farm dating back to the late 1800s. There is even speculation that the farm may have been

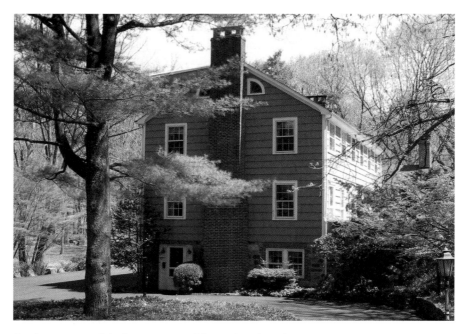

Southern corner of the home converted from a barn by Julia Cross.

the Tower Farm mentioned in local, historical records, but difficult to link to an exact location. The farm may have also supplied produce for the Somerset Inn, an establishment that existed on Mendham Road from 1872 to 1908. As far as the owners can tell, the cottage on the property is the oldest structure located on the site, and may have been built in the very late eighteenth century. Interestingly, a friend of the family has said that one of her ancestors attended a funeral in the cottage back during the time when the coffin used to be brought to the home of the deceased for the service.

The Snyders' house itself used to be a barn that was built about 1820. In the rear of the property is a tile-sided silo that still stands as a remaining testament to the past agricultural use of the property. At one point the property belonged to Colonel Anthony R. Kuser who owned several farms in the Mountain Colony. William Redmond Cross and his wife, Julia Appleton Cross, who had an estate approximately one mile east of this spot, acquired the farm buildings and almost forty-six acres of land from two parcels purchased on May 28, 1937, from Robert H. Schenck and Charles A. Dana. Having designed lovely gardens at her estate on Jockey Hollow Road, Julia had always yearned to design a home. The purchase of the farm gave Julia her chance, and she used her talent for design to convert the barn, which was once used as a stable, into a charming bank house. She

added a pond, making use of an existing stream and fed by a spring on the remaining Dana Estate, and surrounded it with gardens filled with irises, ferns, ivies and water plants. Her intention was to use the home as a summer house and gaze over her creation of pond and gardens from the veranda that she added to the northeast side of the building. The access road to the home used to sit above the current driveway, sweep around the rear of the building where Mrs. Cross had a series of French doors installed, and also existed as a right-of-way for the Schenck and Dana families and allowed the Cross family access to the spring on the Dana property. This strongly implies that the rear of the current building used to be the front when it was a working barn, and later the newly designed home. Unfortunately, Redmond Cross passed away in 1940, and Julia never spent much time at the home, opting instead to rent the property.

Eventually, Julia Cross sold her Lloyd Road house and property to James Clemens Chilcott and his wife, Ruth, on April 3, 1944. The property was next purchased by R. Barry Green and his wife, Kathryn, on July 20, 1953, who subdivided the property, selling a portion of the woods and fields behind the home on March 23, 1962. This land was later developed. The remaining land, house, cottage, spring house and other outbuildings were sold to Arthur Snyder and Beatrice H. Snyder, his wife, on May 1, 1967. Although almost nothing is written to document the architectural and landscaping changes made to the property by the Cross family, the Snyders were fortunate enough to speak with Mrs. Cross when they purchased the home in 1967, and got the information directly from her.

Now, I must pause here to point out two incredible occurrences of ancestral synchronicity that fascinate me. The first is that Beatrice Snyder's fifth great-uncle was Alexander Kirkpatrick, and he was one of the first settlers in Bernardsville (Vealtown), building a house at the foot of the Round Top Mountain area of town in 1736. The second coincidence concerns common ancestral roots. Beatrice Snyder moved into the area with her husband, Arthur, and their children in 1967, which made her family and my family neighbors in the town of Bernardsville and within the New Jersey county of Somerset. If we look back to England between the years 1615 and 1639, we find Beatrice's seventh great-grandfather, Robert Treat, and his ten brothers and sisters being born in Pitminster. During the span of years from 1613 to 1629, my eighth great-grandfather and his six brothers and sisters were born in Charlton Musgrove. Interestingly, it turns out that Pitminster and Charlton Musgrove are both located in the English county of Somerset, for which Somerset County, New Jersey, was named. In addition, almost four centuries ago, the distance between our ancestors amounted to only thirty-three miles. Their discussions in the English countryside in the early 1600s

would have included the death of William Shakespeare, the coronation of Charles I as King of England, Scotland, and Ireland, the beheading of Sir Walter Raleigh and the declaration of January 1 as the first day of the year in the Gregorian calendar instead of March 25. While growing up, my family's home was about 250 yards from the Snyders' house, and our family conversations included talk of the Vietnam War, the music of the Beatles and their release of *Sergeant Pepper's Lonely Hearts Club Band*, the assassinations of Martin Luther King Jr. and Robert F. Kennedy and Neil Armstrong's first steps on the moon. Weaving through an incredible span of history, our families have reached across time, journeyed across an ocean and come to find each other living just across the street.

Traveling the length of Lloyd Road takes one through an assortment of environments comprising field and pasture, ponds, streams, hillsides, woods and valley, and the two ends of the road are very different in appearance. At the northeastern end of Lloyd Road is Hardscrabble Road. This twisted corridor was dotted with small farmhouses that sat precariously on the edge of the hillside and close to the banks of Indian Graves Brook that ran along the western side of Hardscrabble Road between Washington Corner Road and Lloyd Road. In the eighteenth and nineteenth centuries, a sawmill and a blacksmith shop flourished a little further downstream along this secluded brook. This area always had a magical air about it, and I always fancied that elves and gnomes would find this a perfect location to hide in the deep shade among the rocks, boulders and ferns.

Heading north on Hardscrabble Road, one would soon arrive at Washington Corner Road on the left. This area was named after George Washington who camped with his troops not far from this place. As late as the 1930s this road was called Washington School House Road. Just when the official change in name occurred, I do not know. Just north of this intersection used to be an orchard called the Jockey Hollow Fruit Farm that my father used to frequent to buy apples and cider when I was young. It eventually closed around the year 1969 due to the requirement of pasteurization of apple cider that was to be sold. Washington Corner Road leads up a large hill, past a large field on the right, around a left-hand curve, down another hill and around another sharp bend in the road, at which point the original road used to lead straight into the woods and connect with a wagon road, formerly named Valley Road, that used to connect with Lloyd Road just below and northeast of the pond. After negotiating the curve to the right, one arrives at my former school bus stop, which can still be located by finding the large, flat rock on the southeastern side of the road just after the little bridge. At this point one used to be able to follow the gravel road on the left that led to Gary's Lane.

Bus Stop Rock.

Continuing southwest up Washington Corner Road, one eventually passes a pair of gates on the right side of the road before arriving at Mendham Road. The driveway that enters through the aforementioned gates leads to the former Koslosky house, a stone residence that used to host my church's annual spring picnic. Many good meals and three-legged races were had at this spot, but the most notable memory has to do with what lay beneath the ground.

A subterranean passage, originally explained to me as being part of the Underground Railroad, is now said to be the remnants of the old Somerset Inn that was built in this area in 1872, seven years after the conclusion of the Civil War, being used instead by the inn's employees and not escaping slaves. Apparently, it was not considered appropriate for the Somerset Inn's guests to see its employees walking about on the premises, so the tunnels allowed the help at the Somerset Inn to travel underground in order to bring food and other deliveries to the guests in their cottages. Obviously, the date of the inn's construction poses a problem for the Underground Railroad theory. However, other information may be able to shed new light on this mystery, and perhaps link the two explanations.

In 1801, thirty-three-year-old Walter Greacen came from Dutchess County, New York, and built a house on a 116-acre parcel of land, including the same land that would one day be the site for the Somerset Inn. It bears

mentioning that some of the Greacen family information is difficult to corroborate, but here is some of the plausible information I've been able to gather. Mr. Greacen had a wife, Fanny, and went on to raise three daughters who never married but did some extraordinary things with the property. All of the Greacens were said to be enlightened, bold and forward-thinking in nature. Using the environment well, bricks were fired from the clay on the family farm to construct a house, assumingly to replace a clapboard house that had been built earlier. The eccentric eldest daughter, Jane, assisted with brick firing and construction when she was about forty years old. When the building was completed, Misses Elizabeth and Sophia, the two younger daughters, opened a successful ladies' boarding school that enrolled students from Newark, New York and Elizabethtown. Jane helped to teach at the school but found more joy working outdoors, preferring to run the farm in the spring and summer.

Eventually, Jane Greacen took over the farm work entirely when her father became too old, often swinging her scythe, haying, or plowing corn from dawn to dusk. Known as a tough woman, Jane was six feet tall, as strong as a man, wore men's boots, coat, hat and a short skirt. She must have been quite a sight in comparison to the other women at that time. Jane would even take it upon herself to make the farm's produce deliveries, driving her horse and wagon to Newark overnight and returning the next day. At times, Jane's father, Walter, would accompany Jane on these trips. It was during one of these deliveries, on December 27, 1842, that Mr. Greacen supposedly wandered away from the wagon during the night in Newark. Tragedy struck when he apparently fell twelve feet from the canal bridge, which had no railing, at the foot of Market Street. He drowned in the canal at the age of seventy-four, and his body was found the next day. Waiting until after the coroner's inquest, Jane loaded her father's body in her wagon and drove home, alone and heartbroken, through the night to the farm.

At this point the information on land ownership gets a little clouded, but it seems as though the Greacen women mortgaged their property in 1844 to Louis Thibou who, in 1846, transferred the mortgage to the Methodist Bishop Edmund S. Janes, Mr. Thibou's son-in-law. Eventually, Fanny Greacen and her three daughters sold their brick home/boarding school and property to Bishop Janes in 1850. Janes retained ownership throughout the Civil War and the most active time of the Underground Railroad.

After the Civil War, during the era of Reconstruction, Bishop Janes sold the house to Isaac Archer in 1870. It is interesting to note that while Archer held the title to the house, it was Francis Oliver who assumed residency in the house, ran the day-to-day operations, made some modifications and

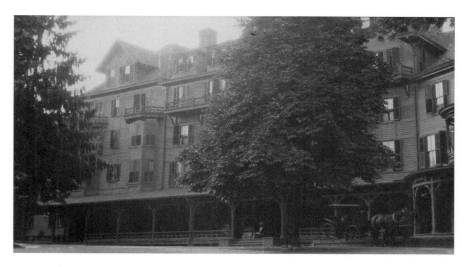

Vintage photograph of the Somerset Inn.

Vintage photo of
George Ingraham
Seney.

turned it into a boarding house. Unfortunately for Mr. Oliver, the boarding house was not a success, so in 1871 the boarding house was purchased and named Highland House by George I. Seney who, in 1872, rebuilt and expanded Highland House and changed its name to the Somerset Inn.

The inn itself, while large, was surrounded by twenty-six other buildings including a carriage house/stable complex, eight guest cottages, a casino, barber, henhouse, laundry, two ice houses that stored ice imported from Mount Pocono, Pennsylvania, two water tanks, four employee buildings and five unlabeled outbuildings. The Somerset Inn operated from May 15 through October 15, and one of the intended purposes for the inn was to provide a place for wealthy visitors to stay while they toured the area and pondered where to build their estates on the Bernardsville Mountain. Produce and milk came from the inn's own vegetable and dairy farms, and recreation included well kept walking trails, a swimming pool built of stone and concrete complete with changing rooms, a thirty by seventy-five foot concert and amusement hall and a tennis court. There was also a nine-hole golf course and clubhouse that was located on the western side of Mendham Road, just one quarter mile from the inn, and situated just south of the former Pfizer Estate and the spot where Lloyd Road meets Mendham Road.

The idea paid off for Seney, as the Somerset Inn became one of the most successful summer resorts in New Jersey, but there was one risk that eventually reduced the landmark to rubble. Built mostly with wood frame and shingle construction, heated by coal and wood and lit by gas, the immense structure was destroyed by a fire on May 6, 1908, just nine days before the start of a new season. Undoubtedly there were hydrants on the property, but there is a touch of irony in the fact that the insurance map for the entire complex included the mention of only twelve fire extinguishers.

Very little information can be found about the structure that was occupied by Mr. Greacen, Bishop Janes and Mr. Oliver, but the fact that this building existed on this site since approximately 1840 may open up the possibility that both explanations for the tunnel could be valid. Since the Underground Railroad reached its peak between 1830 and 1865, the same period of time when Greacen, Janes and Oliver developed this property, it is conceivable that the Somerset Inn's tunnel was built in an area once containing an earlier passage or vault, which could have served as a station for escaping slaves. It is, I believe, an intriguing point to ponder, especially when one considers that the neighboring town of Millington contained a switching station for the Underground Railroad, and the building that would become the Bernardsville Library is rumored to have been a station on one of the routes.

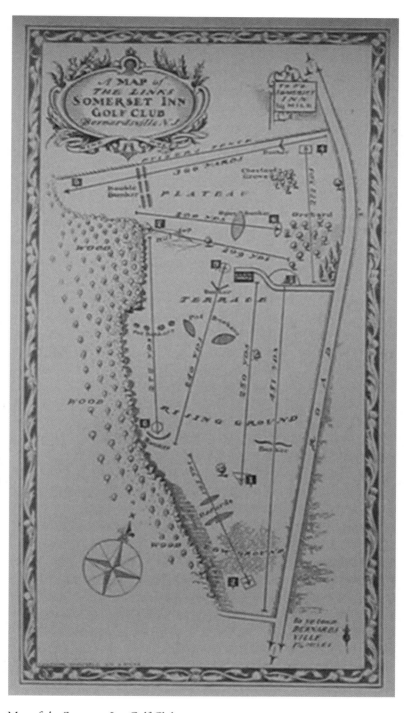

Map of the Somerset Inn Golf Club.

Aside from this concealed passage, the stone entrance pillars along Mendham Road are the only other surviving physical reminders of the Somerset Inn. In time, the resort that George Seney created became the namesake for the region well after the inn's destruction. It seems it may also honor Seney's impact on the area, for Somersetin always appears on maps in the exact location of George I. Seney's former home and not that of the inn itself. One will, however, find two variations of spelling when it comes to the area's name. Appearing on zip code maps for the state of New Jersey and United States Geological Survey maps, Somersetin seems to be the most widely accepted spelling as opposed to the occasionally used "Someseten," which appears on some maps.

Mendham Road is the most traveled of the four roads that surround the former Lloyd Estate, and it is a proud thoroughfare. Turning left at the end of Washington Corner Road and heading southeast, Mendham Road takes one up a small hill and along old, stone retaining walls that are common to this area. At the top of this small hill one can look northeast to the left and get a good view of the site of the former Big House—the large, grand home and one time center of activity of the former Lloyd Estate.

Passing Pfizer Road on the right, one soon comes to a field on the left where one's eyes can look down to a pond and the place where we began this circuitous road journey. Southwest and directly across Mendham Road from the pasture and the southwestern terminus of Lloyd Road is the shingled and half-timbered house of Robert Seney, George Seney's son, built in 1882. Robert Seney hired the prominent New York architectural firm Lamb and Rich to design the house. Lamb and Rich went on to design Theodore Roosevelt's country house called Sagamore Hill, which was built two years later in Oyster Bay, Long Island, and many of the buildings at Dartmouth College. This Seney property was sold in 1891 to Charles Pfizer, son of the founder of the Pfizer Pharmaceutical and Chemical Company. The estate was named Yademos, which is "Someday" in reverse. Yademos once hosted Mary Pickford, star of the silent movies, and scenes for her movie *Madame Butterfly* were shot here in September 1915—an event that caused quite a stir in the local newspapers at the time. This estate was once known for its magnificent Japanese gardens that cost Mr. Pfizer seventy-five thousand dollars to build and were tended by, of course, Japanese gardeners.

Okay, are you ready for another connection between this home and the Roosevelt family? Charles Pfizer died in Yademos after a long illness in 1929 and just before the stock market crash. Mrs. Pfizer stayed in the home until 1933 when the property was sold to Jackson Martindell, a financial lawyer from New York City. He and his wife made the property their

permanent, year-round residence, and planned to restore the gardens to their former glory. But what did Mr. Martindell actually discuss within the walls of Yademos? On December 20, 1934, the *New York Times* printed a story titled "Reds Plot to Kidnap the President, Witness Charges at House Inquiry." The witness was Samuel Glazier, an army captain from Baltimore, Maryland. Glazier was in charge of a Civilian Conservation Corps Camp at Elkridge, Maryland. The article states that Jackson Martindell, a New York lawyer, had discussed with Captain Glazier the forming of the "American Vigilantes" with a half million members and backed with seven hundred million dollars. Martindell is said to have mentioned that he knew that the policies of Franklin Delano Roosevelt would lead to a revolution, and when that time came, he would be ready to take over the reins of the government as its dictator. According to the article, "a Red plan was being widely circulated in Communist circles to create civil war during a general strike, invade the White House, kidnap the President and his Cabinet, and take over the government and supercede it with a Soviet State." According to another source, Martindell was never called by the House Committee to challenge or confirm the testimony implicating him in the affair. Yes, truth is often stranger than fiction, and for Jackson Martindell the name Yademos might have encapsulated dreams of personal, political significance.

Environments

Somersetin is blessed with a plethora of natural environments and settings. From open fields to dense woods and from small streams to expansive ponds, there always seemed to be an adventure waiting to happen, nature's beckoning sounds and a place ripe for discovery by a pair of young eyes.

The word "field" conjures up different, mental visions for people, depending on their frame of reference. To someone from a farming background, visions of large pieces of land planted in rows of corn would come to mind. Others may envision fields of wheat. To a boy growing up as I did in Somersetin, a field was any overgrown area devoid of trees, and it was usually filled with milkweed, goldenrod and wild grasses that had gone to seed. Nestled beneath this luxuriant cover were rabbits, mice and an occasional Common Garter Snake or Eastern Box Turtle. Flitting overhead were butterflies, beetles, bees and other flying insects, and the whole area might be crisscrossed by herd paths made by the large numbers of White-tailed Deer that also called the area home. The field could be many acres in area, or perhaps just a clearing in the woods—it didn't matter—and

there were several from which to choose. What remained consistent were the activities and the ensuing memories that became forever ingrained in our minds.

Somersetin was surrounded and infused by large and small wooded tracts of land that were inhabited by a wide variety of birds, many squirrels, chipmunk, fox, deer and other animals. Cicadas would fill the treetops with their buzzing, pulsing drone during days of late summer and be replaced in the evenings by the katydids singing their ratchety, staccato, onomatopoetic lullabies. Existing in varying successions of growth, the woods provided shelter for the wildlife, and privacy and a source of serenity and adventure for the human inhabitants. Closest to our home were two fairly large areas often visited by my friends and me. Another, less visited, lay further away.

The first was the area commonly referred to as the "Woods." Okay, it wasn't the most creative name, but it served its purpose. When any one of my friends or I mentioned the Woods, we knew exactly what and where we were talking about: an irregularly shaped piece of ground that bordered the northwestern side of our driveway, flanked both sides of Gary's Lane and continued to border the northeastern side of Gordon's Lane heading down toward the pond. Encompassing the remains of an apple orchard amongst other mature trees, hillsides and streams, the Woods was a veritable cornucopia of natural resources and amusement.

The second wooded area we commonly visited stretched out across the southeastern edge of Lloyd Road. While this area had no particular name, going across the road to play meant you were going into this area of woods. While not as varied in terrain as the Woods, this area held its own unique claim to fame. We saw mystery in its tangle of vines, tall trees, low branches and undergrowth, and even found a way to make some money on this land in a unique and spooky manner.

The third wooded area was further away and diagonal to Somersetin. If one goes to the bottom of Lloyd Road and turns right (southeast) onto Hardscrabble Road, one will see a mature, wooded hillside past the houses on the left and across the brook. Under closer inspection, however, secrets would be revealed about the former use of this land and the treasures it still retains. It is a sacred and historic spot, having seen use by Native Americans and Revolutionary War troops.

Poking about in stream beds has to rank high on the list of favorite childhood activities. It seems as though I must have spent, collectively, several months of my young life overturning rocks, building small dams and pools and examining the wildlife living in and along the stream.

The stream to which I am referring is the one that parallels our old driveway and empties into the original Lloyd Pond. From the pond, it spills

over the dam and parallels Lloyd Road down to Hardscrabble Road where it joins Indian Graves Brook. Bathed in cool shade, both the stream and the brook are lovely, babbling waterways filled with rocks and lined by the deep green of spicebush and ferns, the orange blooms of jewel-weed and flitting damselflies.

The ponds were also treasure troves for young explorers. Inhabited by frogs, sunfish, bass, ducks, geese, turtles and an occasional snake, there were always new things to be seen and many seasonal activities to hold our attention. The pond at the top of Lloyd Road was built by the Rankin family and was not in existence during the Francis G. Lloyd tenure. However, the lower pond was part of the Lloyd Estate, and being the larger and more obvious of the two, received more attention from my friends and me.

4

Places to Remember

*"Good Heaven!" said Scrooge, clasping his hands together, as he looked
about him. "I was bred in this place. I was a boy here!"*
*The Spirit gazed upon him mildly. Its gentle touch, though it had been
light and instantaneous, appeared still present to the old man's sense of
feeling. He was conscious of a thousand odours floating in the air, each
one connected with a thousand thoughts, and hopes, and joys, and cares
long, long, forgotten.*
*"Your lip is trembling," said the Ghost. "And what is that upon your
cheek?"*
*Scrooge muttered, with an unusual catching in his voice, that it was a
pimple; and begged the Ghost to lead him where he would.*
"You recollect the way?" inquired the Spirit.
"Remember it!" cried Scrooge with fervour—"I could walk it blindfold."
*"Strange to have forgotten it for so many years!" observed the Ghost. "Let
us go on."*

—Charles Dickens, *A Christmas Carol*

KENNEL FOUNDATION

Across the yard from my front door was a row of trees and barberry bushes
on a little hill. Situated among this growth was a reminder of the earlier
history of our house and grounds. A brick wall, perhaps one to two feet high
that disappeared into the hillside, existed as the only surviving portion of
the famed Walescott Kennels, once the pride of the estate. Used for housing
the Lloyds' more than one hundred Scottish Terriers, the kennels were torn
down after the estate was dissolved.

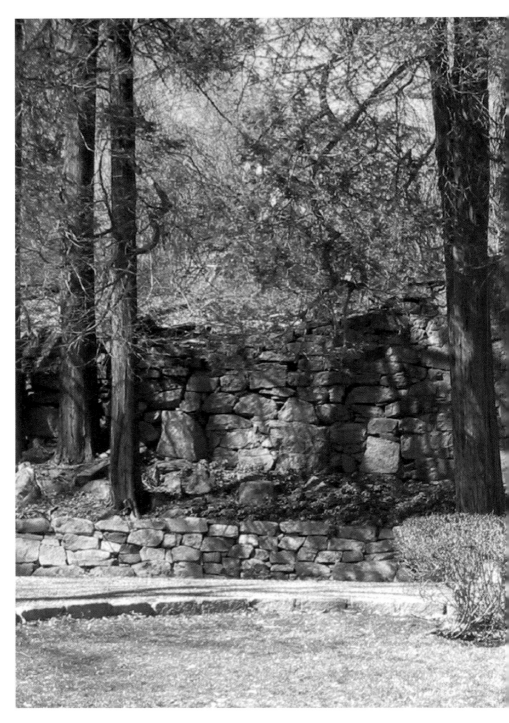

Root cellar at the Brick Cottage.

Besides golf, the dogs were Mr. Lloyd's recreation, and he was among the first individuals to bring Scottish Terriers into America, breed and show them. Apparently on Saturday afternoons, Mr. Lloyd delighted in running about thirty of his dogs through the woods and around the pond below my former home. Usually the last of them would not be collected until Monday. The dogs did not come cheap, and Mr. Lloyd paid up to $2,500 for one individual champion—a tremendous price in those days. Bert Hankinson used to joke that one dog, which had cost $1,100, was kept in a kennel that was probably not worth more than twenty-five dollars. There was never any interest in selling any of the terriers at any price, but Mr. Lloyd would occasionally give a dog to a visitor he liked.

Winners of national and international competitions, the dogs were important to the Lloyds and to their kennel man Mr. Hankinson and his family. Among the most successful dogs were Champion Walescott Invader, Champion Walescott Whim, Champion Walescott Maister Wullie, and Champion Walescott Wag. Mr. Lloyd didn't want to know how much the dogs cost him, saying that if he knew, he might decide he couldn't afford it. Instead, he had Bert Hankinson send all the bills to his New York office where they were paid. Just how good were the Walescott Kennel terriers? Try this on for size: It was not unusual for Walescott to win the vast majority of prize money at many shows and take first, second and third places in some of the classes. In 1920, Mr. Lloyd's kennel benched twenty dogs at the Westminster show, tallied twelve first place awards, both winners and the best of breed!

It is said that Mr. Lloyd had a great deal of affection for his dogs and would not have any dog destroyed as long as its health was fair. There is one report I have read that told of a sick terrier being nursed inside my former home and eventually dying overnight with its head on the bottom step. The dog was buried somewhere in the old gravel pit at the end of Gary's Lane. Still other reminders of the dogs could be seen on our windows where little paws had scratched away some of the mullions between the lower window panes. I sometimes sat on my lawn in the early evening and thought about what it must have sounded like to hear the dogs barking in their kennels and scampering about the grounds. Oh! If only those remaining brick walls could speak!

TREASURE SITE

Not far from the top path that led northeast and away from the small house, which sits near the former estate's chicken runs site, was a patch of earth

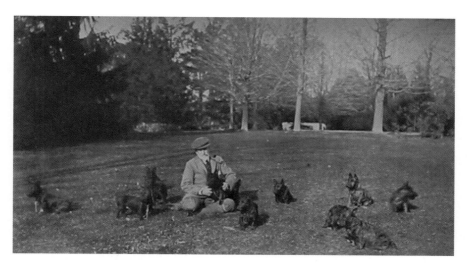

Francis G. Lloyd and his terriers on the lawn of The Maples.

that concealed a sunken treasure. This treasure had nothing to do with jewels or precious metals, but the riches it contained satisfied a young boy's fancy just fine. The site in question is one of the crumbling remains of a foundation for one of the Lloyds' temporary summer kennels. Set back in a clearing in the trees, it was an easy jump down of three to four feet that put one on the bottom of a concrete walled depression we called the Pit.

Explorers as we were, my friends and I would always find something of interest to claim as our own at this place. Animal bones were the popular item, and I can only surmise that small animals would, over time, fall into the Pit and would perish as a result of being unable to escape. Bones of rabbits, weasels, mice and opossums were discovered, but the skulls were the most prized. Through the years, we amassed a considerable collection of bony remains, and we worked like archaeologists at a dig, celebrating whenever a discovery was made.

Chicken Coop

Nothing quite perks up a young boy's interest like animals and secret places, and these were both found just steps away from my front door. The Rankins kept chickens in one of the former Lloyd chicken coops that butted up to the western corner of our property. It was an area well hidden among the trees and sumac, and virtually called out to be visited by children, especially those with a sense of adventure.

The coop was not officially a place where my friends and I were supposed to be, probably due to the fact that our visitations alarmed the chickens and caused them to squawk as though the hatchet man himself were chasing them. However, the draw was much too powerful and enticing, and undercover visits were often planned and executed with the skill of secret agents. Creeping through the tall grass in the back of our property, it was easy for a child to crawl in between the briars and up past the hedges where the chicken yard was located. Not very well protected, the yard was surrounded by a five-foot, chicken-wire-mesh fence. The trick was to move slow enough so that the chickens were not upset, lest they commence with their cackling alarm and give us away.

The birds themselves were beautifully colored in shades of brown, orange and red, and there was an iridescent quality to many of the feathers. Roosters were the bravest of the fowl and were among the first to strut up to us. As often as we could, we would bring bread crumbs, crackers, or bird seed for them to eat. If we were lucky, there would be fresh feathers to be found on the ground and taken in trade for the food.

It was common to find the remains of a chicken kill along the borders of the fence. During the night, weasels would steal into the yard or the coop itself and kill a bird, causing quite a racket that could be heard from my bedroom. Not being able to get the chicken through the fence, the weasel would tear the bird apart and pull what it could through the fence. Chicken skulls, feet, feathers and other bones and scraps would be left over as proof of the nocturnal kill.

Just above the row of hedges in our yard and across an overgrown, wooded area was the large shell of another former chicken coop from the estate era. With its old fashioned vents on its roof, broken windows and dilapidated wooden interior, it was ripe for exploration. Although not used for chickens any longer, the structure was still inhabited by a number of other creatures. Stepping gingerly across the wooden floor beneath whitewashed walls and rafters, I occasionally saw creatures such as owls, mice, snakes and spiders. A feeling of purpose and functionality permeated the barn, and I remember feeling a little bit sad that it was no longer cared for, but instead left to rot away as an empty shell of its former integrity. Nevertheless, it served my friends and me as a place for many hours of exploration.

Estate Treehouse

On the top of the hill just behind our garage stood a very old Black Cherry tree that marked the edge of our property and the overgrown area leading

up to the old chicken coop. Up in the crotch of this tree were the remains of boards that once served as a treehouse for a boy much like I was.

When the Lloyd Estate was intact, the kennel manager from 1917–1920 had a son named Norman Hankinson. For hours Norman used to sit perched atop this cherry tree, fifteen feet up or so, surveying the grounds and dreaming the dreams of a young boy in the early 1900s, maintaining a pirate's foremast lookout over the orchard or piloting an airplane through the sky. By the time I was big enough to climb the tree, the boards were not of much use other than serving to help me balance. As it was, these boards were never taken down, and they served as a reminder that I was not the only boy who had established memories in this place. Somewhere there was an elderly man with pictures in his mind that were very similar to my own, and I have to say that I felt as though a part of him was still in that tree keeping watch. We had a connection, Norman and I, and it made me feel secure and good.

Willow Fort

Just above the old kennel wall grew a spreading Swamp Willow tree that served as a delightful natural jungle gym and fort. The branches of this tree seemed to stretch in every possible direction and spread out so that there was always a convenient, flexible limb on which to step or perch. Shaded by the soft willow leaves overhead, many summer hours were spent climbing or just sitting in the shade of this tree. Underneath there were pockets of secluded space surrounded by dense foliage, just perfect for forts complete with secret entries and exit ways. I can remember many a game of Cowboys and Indians, or Cops and Robbers, played out in and around the willow fort tree, which also bore witness to secret meetings and club headquarters as well.

The Trinity of Trees

In the year 1606, the Dutch painter Rembrandt was born, William Shakespeare completed *Macbeth* and Galileo Galilei invented a thermometer based on the expansion of gas. At the same time, a tiny Red Oak acorn had just taken root in the soil of an area that would one day be called Somersetin. This magnificent tree, which I like to call the Sentinel, still graces the front yard of the Brick Cottage, stretching upward and across the lawn and driveway, almost as if it were embracing the former estate.

The Sentinel.

Of course, the Lloyd Estate and the current residents would be relative newcomers to this tree's list of people and events it has witnessed. Appreciate with me, for a moment, something exceedingly stalwart and graceful that has managed to prosper, according to an arborist, through 400 years of history. If the Sentinel had eyes to scan the acres around it, what would it have seen? Going back in time before the estate, this tree was certainly an arboreal witness to the movement of Washington's troops during the American Revolution as they camped not far from its shadowed trunk. It would have welcomed the first Europeans to the area in the early 1700s, and the tree's early life would have been shared with the Lenape people moving through the unsettled land, perhaps collecting its acorns for food. This tree is living history, and its commanding presence still towers over Somersetin, watching and waiting for life to play itself out underneath its sheltering limbs.

On a blustery autumn's day, the falling leaves of the Sentinel would certainly mix with those of another tree whose branches have hovered over the area for years. Although not the eldest statesman, the Feldmanns referred to it as the Grandfather tree, and it is a fitting name for such a noble tree. Serving as the base of operations for a large portion of our play at the Feldmanns' house, this enormous Yellow Poplar, also called a Tuliptree, dominated their back yard. Almost four feet in diameter, this natural giant towered above the homes in the area, and along with the Double Oak at the top of our driveway, could be easily seen from Mendham Road. It was our backstop for baseball, our end zone for football, a source for finding caterpillars and Woolly Bears and an appreciated provider of shade.

Withstanding snow, ice, thunderstorms and droughts, the Grandfather tree remained steadfast. The base of its trunk was a good place to sit and dream. It was obviously much older than our families, and it is interesting to think that the tree saw the creation and dissolution of the Lloyd Estate, certainly eavesdropping on the conversations of Chester, the estate's chauffeur, and his wife, Hannah. It saw the development of the Somersetin land from a farming community to a country community of modern professionals, and the progression of horse and carriage to automobile.

Rounding out the trinity of trees is the Double Oak, so named for its two trunks, which stood at the top of our driveway. It is a magnificent Pin Oak with two trunks that easily dates back to approximately 1770. The tree's duplicity mirrors the divisive events to which it bore witness, such as our War of Independence with Great Britain, the Civil War that not only temporarily divided our nation but sometimes pitted brother against brother and unfortunately the dissolution of my parents' marriage, which sent my family heading in two different directions from a common beginning.

The Grandfather Tree.

The Double Oak.

This tree had a bird's-eye view of Mr. Lloyd's Walescott Kennels. Over time, the scampering of Scottish Terriers gave way to the scampering of children, and it was the foliage of this tree that provided the fodder for many leaf piles, which beckoned my friends and me to jump into their luxuriant depths. The sound of these leaves crunching under my feet is still fresh in my memory, and these leaves also provided fuel for one of the most sensuous, pungent and vivid scents from my childhood—the smell of burning leaves. Raking the Double Oak's leaves and watching the smoke of the leaf fires wafting out of our incinerator were always the definitive harbinger of winter.

Going Back One Billion Years

If one journeys down to Hardscrabble Road and turns right, passing Jockey Hollow Road, one will find about one linear mile's worth of hillside on the northern side of the road to be explored that relates to a very early part of this area's history. Different layers of history can be figuratively peeled away in this area, much like an onion skin, to expose five distinct events and the time periods that accompanied them.

Approximately ten thousand years ago, the Wisconsin Glacier retreated. This flow of ice, upwards of two miles thick in some places, terminated close to this area and dramatically affected the land in its path. It scoured the earth beneath it during its advance, and upon its melting and retreat, deposited large amounts of rocky debris that had been scraped up and collected by the ice. On the sides and ridge top of this hill, and almost anywhere else along Hardscrabble Road and in the surrounding area, are huge boulders of granite bedrock. This rock is probably one billion years old, being part of a spur of mountains that runs from Pennsylvania to Vermont known as the Reading Prong, and is the oldest exposed rock in the eastern United States.

Let's put that in perspective. The Earth is about 4.6 billion years old. Reptiles appeared about 325 million years ago. By comparison, a widely accepted view among current anthropologists is that the modern human species originated in the African savanna between one hundred thousand and two hundred thousand years ago. This means that the exposed rocks on which one can gaze and climb on the crest of this hill have witnessed the age of dinosaurs, extreme climate changes and the development of man. Talk about touching history—just think of the stories these rocks could tell!

Granite boulders deposited by the Wisconsin Glacier.

LOGTOWN

Near the very top of this hill are large cuts, pits and gullies in the earth. Upon first sight, they are puzzling because they are not congruent with the surrounding slope of the land. However, they are the remnants of another completely different use of this area and its resources. From as early as 1723, when a fulling and textile mill was established, through the mid–1800s, this area along the brook and east of Somersetin was known as Logtown, due no doubt to the piles of logs that were processed at the area's sawmills.

Early Logtown residents included farmers who came to this little valley to raise sheep for their wool and flax for the textile mill. Through those years, Logtown included three sawmills, a carpet-weaving shop, a grist mill, a general store that also served as a Revolutionary War commissary, mechanics' shops, a fulling mill, a blacksmith's shop and a forge. Eyre's Forge, dating back to the 1700s, was located on the old Forge Road, just north of where Old Army Road meets Hardscrabble Road. Forge Road no longer exists, but one can still trace its former path through the Scherman-Hoffman Wildlife Sanctuary and northward beside the Passaic River.

Sign of a bygone era.

It was during this time that some exploratory holes and cuts were made on the Logtown hillside to mine iron ore. The ore was dug largely by hand and loaded into carts where it was then taken to local furnaces. The resulting iron produced by these furnaces was used by blacksmith shops, including one that used to be located just across from the entrance to the old Forge Road. As time passed, the industrious nature of the Logtown settlement gradually dissolved, and the name gave way to Hardscrabble.

Snaking across both sides of Hardscrabble Road runs a stream known as Indian Graves Brook. This somber name has an interesting piece of history connected to it. Native Americans, members of the Lenape tribe, a name meaning "common" or "original," used to inhabit this area of New Jersey. They were a quiet, friendly people with advanced agricultural skills who cultivated much of what they ate, including beans, squash, pumpkins and corn. Having a written language, they were also a monotheistic society that believed in the immortality of life.

The wooded slope on the northern and eastern sides of Hardscrabble Road was sacred to them and used as a burial ground for the Lenape tribe members. It is, today, a very quiet place and is owned by the National Park Service and the Audubon Society. Trails crisscross the area, and there are several very large rocks on which one can sit and rest. Early burial

customs for the Lenape included interring the corpse in a fetal position. Later this was changed as European influences were adopted, and the deceased were laid out in an extended fashion, although the depth of the graves continued to be very shallow. In addition, a package of food was included in the grave to serve as sustenance for the spirit on its journey into the next life. Once buried, no one in the tribe ever spoke the name of the deceased again, so as not to arouse sorrow in the surviving family members.

I have always been strongly impressed by a feeling of melancholy on the hillside. Surrounded by tall beech and oak trees, it is common to sense that there is a presence aware of your movements, almost as if it is guarding the area. It is hallowed ground, and the feeling is strongest in an area just off the road by a little bridge that crosses Indian Graves Brook. A spur trail of Patriot's Path begins here and leads up to the Bensel-Cross Estate and Jockey Hollow. More than once I have caught myself looking over my shoulder, expecting to see someone, but I never have. It can be an unnerving feeling, and, although it is a peaceful place, I have felt it better to quicken my pace in this area from time to time.

Funeral Song
(A Native American poem)

You're like a drifting log with iron nails in it.
I built my house from that log.
I hope you float in like that log did
on a good sandy beach.
The sun goes into the clouds
like you go into our great mother.
That's why the world is so dark.

Perhaps some of the unsettling vibrations I have felt on the hillside above Indian Graves Brook have another explanation. Several yards up the spur trail of Patriots' Path off of Hardscrabble Road is another historical point of interest, for it was the spot on which General Washington's New Jersey Brigade built their huts during the Revolutionary War.

During the winter of 1779–1780, General George Washington had his army encamped in the Logtown and Jockey Hollow areas while he made his headquarters in Morristown. This particular winter was the most severe and ferocious of the entire Revolutionary War for the American troops due to its heavy snows, bitterly cold temperatures and frigid winds. In fact, the temperatures during the month of January 1780 climbed above zero

degrees only once. Interestingly, one of the reasons why the Valley Forge, Pennsylvania, encampment is better known has much to do with the fact that approximately 3,000 men died from the conditions there, primarily due to disease, as compared to Jockey Hollow, where the death total was just over one hundred.

Still, the conditions were extremely poor for the soldiers in New Jersey. With no less than twenty-eight snowstorms occurring during this area's worst winter of the century, up to four feet of snow on the ground and drifts over six feet deep blocking supply roads, the men did their best to provide themselves with shelter and food and preserve their torn coats and tattered clothing. As one can imagine, food supplies dwindled, and the New Jersey Brigade, forced at times to eat tree bark to survive and sleeping on beds of loose straw, often with only one blanket for every three men, faced starvation, disease, exposure and their share of death. Somewhere in the area are even the graves of two officers among those of the other men who did not survive the winter.

Logtown actually had a commissary that sold supplies to the troops, but the buckles, shoes, belts and other equipment from this establishment were procured mostly by officers. The commissary was located in what is now a beautifully restored private home, known today as the Reynolds-Scherman House. Built of fieldstone, it graces the intersection of Hardscrabble Road and Chestnut Avenue. Originally built for Samuel Reynolds, it was later owned by the Scherman family from 1921–1981. Mr. Scherman was the founder of the Book-of-the-Month Club, and the house was used for summer and weekend entertaining of many notable authors and celebrities. The Logtown area actually retains much of its charm due to Mr. and Mrs. Harry Scherman, who, in 1965, donated land for both the preservation of the New Jersey Brigade site and the beginning of the neighboring Scherman-Hoffman Wildlife Sanctuary.

During December 1779 more than 1,000 simple log huts were erected by Washington's soldiers from the surrounding 600 acres of timber. Each hut was built to a standard size of sixteen feet long by fourteen feet wide with a peaked roof over walls measuring seven feet high at the eaves. Each hut also contained a stone hearth and chimney where fires were tended for cooking and to provide warmth. Approximately seventy-five of these huts were erected on this very hillside along Hardscrabble Road by the New Jersey Brigade, commanded by Brigadier General William Maxwell.

Arriving at Elisha Ayers' Forge, a site just across from the eastern end of Old Army Road, and setting camp just north of this spot in Ayers' Field, the troops began construction of their shelters on December 17, and the men moved into their primitive huts on Christmas Day. If you follow the signs

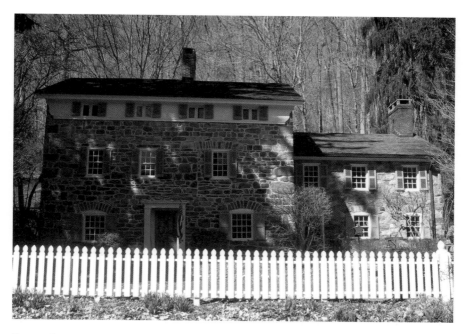

Former Logtown commissary.

on Patriots' Path you will soon see the site of one of these huts. The area is now part of Morristown National Historical Park, yet it is seldom visited, as it is a walk-in site only. However, it provides one of the most direct points of contact with actual physical structures from the Revolutionary War. Set among the trees are the stones of an original hearth that once contained the fires of soldiers over 226 years ago. It is fairly easy to see where the walls were at this site, and to get a sense of the cramped living conditions that once existed here.

My interest in this area's Revolutionary War ties reminds me of the incredible personal sacrifices that have been and are still being made for the sake of our liberties. On a personal level, they also remind me of my own family's links to individual freedoms and this country's military engagements. During World War II, my father, Warren, served in the U.S. Navy and was captain of a ship within the chain of Aleutian Islands of Alaska. His father, Eugene, was also a navy man, serving in World War I. My fourth great-grandfather, Roger Haskell, followed in his father's footsteps in service to his country. His father, Zachariah, had fought in the French and Indian War and died in service at Crown Point, New York, in 1759. Zachariah's wife, Keziah (Goss), was a third great-granddaughter of William White, a passenger on the Mayflower who risked a great deal in the name of personal

and religious freedom. Roger's great-grandfather, Mark Haskell, my seventh great-grandfather, was chosen to serve on a jury to try the so-called witches of Salem, Massachusetts. Not believing in the more or less popular schism of the day, Mark left Salem the day before the trial and helped settle the town of Beverly, Massachusetts.

Getting back to Roger, he served in the Revolutionary War, taking part in the Quebec expedition, the Battle of Bennington, and the Battle of Saratoga. Indeed, after General Burgoyne's surrender at Saratoga, Roger was among one hundred picked men who escorted General Burgoyne to George Washington's camp on the Delaware. After the war, Roger was granted a $42.50 pension for his services, but it was never drawn. Roger's brothers, my fifth great-uncles, John and Simeon, also fought in the Revolutionary War where they took part in the Battle of Saratoga and the Battle of Monmouth, and saw action on General Sullivan's campaign to Rhode Island where John was wounded.

Bensel-Cross Estate

Continuing up the Patriots' Path a half mile or so will lead past the Bensel-Cross Estate section of Morristown National Historical Park before reaching, in another mile or two, the primary section of park and its fine interpretive center with much information on this part of our nation's history. The Bensel-Cross Estate, known as Hardscrabble House during the Cross ownership, was actually built in 1904–1905 by Major John A. Bensel and his wife, Ella, on 204 acres they had originally named Queen Anne Farm. Following Mr. Bensel's death in the house in 1922, his wife sold the estate to the Cross family who purchased it in February 1929 and made a few architectural changes to the home. William Redmond Cross, aside from being a successful banker, was also the president of the New York Zoological Society and American Geographical Society, and his wife, Julia Appleton Newbold Cross, was a well known horticulturist. Although Redmond Cross died in 1940, Julia Cross, who was a descendant on her mother's side of Thomas Jefferson, remained on the estate until she passed away in 1972. In 1975 the estate's 165 acres became part of Morristown National Historical Park and adjoined the 25.4-acre New Jersey Brigade Site that had been donated to the park in 1969. This gracious estate now includes a mansion house with beautiful stone, tile, and stucco architecture, mature gardens and a five-story tower built of stone and wood.

The early twentieth century landscape of the Bensel-Cross Estate is typical of the Arts and Crafts period and includes a formal perennial

Original 1779–1780 hearth from the New Jersey Brigade.

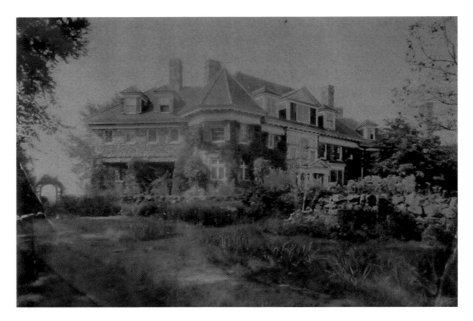

Vintage photograph of the Bensels' Queen Anne Farm.

garden designed in 1930 by the noted landscape architect Clarence Fowler, an informal garden of native plants, a 200 foot long wisteria and kiwi-covered pergola, a Mountain-Laurel alley and a number of diverse species of trees. Indeed, all of the botanical features around the home were a source of immense joy and pride for Mrs. Cross and her head gardener, Anthony Sailer, who won many exhibits at flower shows with Julia Cross.

At the rear of the house is a magnificent Silver Maple tree I've always called the Pilgrim tree, since it was rumored to date back to the time of the Pilgrims' arrival in Plymouth. The tree is huge, in fact it has a trunk diameter of seventy-five inches at a point four and a half feet above the ground, but it does not date back to the Pilgrims. Although there is a Silver Maple near Backus Woods in Ontario, Canada, that is just over 380 years old, this species rarely survives that long, and there are documents that record the Bensel family planting their Silver Maple in 1906, at which time it was probably ten years old, making the tree one hundred and ten years old at the time of this writing in 2006. Silver Maples are the fastest growing species of maples, increasing at a rate of one-half to one inch per year in diameter, and given the data we have on the tree, the tree's diameter increased at a rate of .681 inches over its one hundred and ten years. This falls perfectly within the growth parameters for the species. In my mind, it

Wisteria pergola and formal perennial garden at the Bensel-Cross Estate in early spring.

is time to publicly dispel the Pilgrim tree rumor, and in the same breath, give the tree an official name. Since there are few references to the family that originally created the estate and planted this tree in its place of honor beside their home, I believe it is very right and fitting to pay tribute to them by dubbing this colossal specimen the Bensel tree.

The tower, designed for both water supply and observation, commanded a view that must have been stunning during the early years of the estate, as the trees at that time were approximately half the tower's height. Today it looks odd to have this tower set in the midst of tall trees, but one can still see where the lower and upper observation deck used to attach to its exterior. Missing from the top of the tower is the windmill that once turned the pump to fill a large copper tank at the top of the tower. This tank, in turn, supplied water to the estate buildings by means of gravity. Today, the tower is still the source of water for the estate buildings, but the water is pumped directly to the buildings, bypassing the tank. When I was a child, the father of one of my friends was employed by Mrs. Cross as caretaker of her estate. This allowed us to roam about the estate, and even secretly climb the stairs inside the tower. I can remember the stairs as lacking in stability, and my friend and I literally risked serious injury or death climbing to the top, but we were very young and thought of it as nothing more than an exciting day's adventure. The tower is now locked up tight, and I'm not surprised.

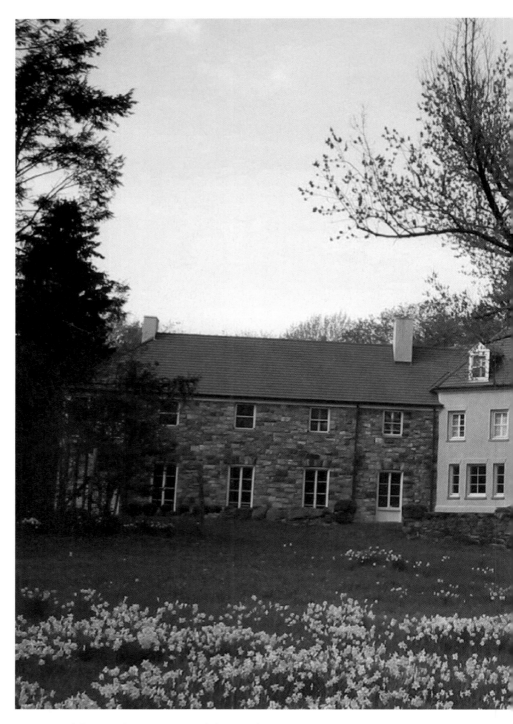

Rear view of the Bensel-Cross Estate and the Bensel Tree.

Bensel-Cross Estate tower.

The serpentine drive that once serviced the estate winds through the thick, established woods around Hardscrabble House, past a chalet-style gatehouse and down through two granite pillars and walls that flank its terminus at the intersection of Jockey Hollow and Hardscrabble Roads. It doesn't take much effort to imagine the horses and carriages climbing the drive and carrying their passengers of men donning top hats and ladies in long, elegant dresses.

The Sand Pit

Down our driveway, through the Woods and directly opposite the spot where the northwestern end of the old wagon road we named Gary's Lane merged with a neighbor's stone driveway is a place we called the Sand Pit. The Lloyd Estate referred to this area as the gravel pit, but I remember a horseshoe-shaped, sandy embankment opposite from the stream.

Surrounded by a large field, the Sand Pit was witness to many of my comings and goings throughout my years at Somersetin. First of all, there was the stream and small pond to explore. This was usually done with my best friend, Rich Feldmann, and it was a carefully guarded activity due to the fact that the owner of the pond would chase us away if he saw us. Nevertheless, it was a bountiful area filled with bullfrogs, leopard frogs, turtles and dragonflies.

Of course, there was a period in time when I would pass the Sand Pit twice a day as I walked to and from the bus stop. At times I would think about a story which Norman Hankinson wrote for the *New Yorker* magazine called "The View from the Middle" in which he told of growing up on the Lloyd Estate while his father was the kennel manager. One particular anecdote in the article described the burial, mentioned earlier, of one of Mr. Lloyd's champion Scottish Terriers in the gravel pit just before an evening thunderstorm. Other times I would stop long enough to run up the sandy embankments, toss pebbles into the stream, strip goldenrod stalks to throw like spears, or explore along the edges of the road and field among the tall grasses and wildflowers. Never looking for anything in particular, I was always entertained by the natural riches of the area.

Major Trails

There were several footpaths that existed on or near Somersetin that provided easier access to homes, bus stops and school for children. One such

Spring house beside the trail to school.

small path started at the extreme eastern corner of our property, down by a huge oak tree that also served as one of our property markers. The path mirrored the course of the little stream at the bottom of the hill and led northeast toward our driveway. Being a very secluded spot, it was not as well traveled as some other paths in the neighborhood, but it was perfect for quick trips to the mailbox. Running through a mix of birch, ironwood and spicebush, the path met up with Gordon's Lane just above the small pool.

Another trail led north and away from the house that sat just up the hill from our home. This was probably the shortest path, being only about twenty-five yards long. Beginning at the end of the cottage's driveway, it shot straight through the Woods and quickly spilled out onto the front yard of another home that had a gravel driveway leading down to the field, Sand Pit and the far end of Gary's Lane. Not any shorter than the route through Gary's Lane, the top path offered an alternative journey to the bus stop on Washington Corner Road.

The granddaddy of all trails was actually a series of paths, once a private road in the early 1900s, which led from Lloyd Road to the elementary school on Seney Drive in Bernardsville. Most of this trail no longer exists, having fallen victim to development, but it offered a fantastic walk through some delightful woods. Pretty much a straight shot, one would begin by

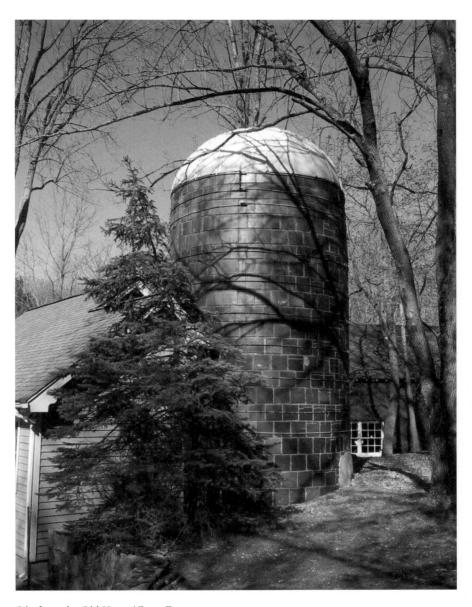

Silo from the Old Kuser/Cross Farm.

exiting Gordon's Lane on Lloyd Road, turn left and travel about twenty yards or so before making an immediate right up a long, straight, paved driveway. This part of the route passed a stone spring house that is more than a century old, and eventually led up between a few old homes of various ages, one of which has pegged beams that are visible in the attic. It used to be a farm outbuilding until being converted to a home in the 1930s, and has been owned by the Mullen family for many years. One of the other homes is thought to date back to the very late 1700s, and it can be seen from this driveway sitting in front of a silo, garage and barn. This entire inclined driveway was Skipper territory, known for the dog that believed his sole purpose in life was to chase and taste anything that moved, so one always kept an eye out for this example of "man's best friend" on this portion of the journey.

After arriving at the top of the hill there was a double-tracked, truck path that continued straight into a corridor filled with goldenrod, wild phlox and sumac flanked by Tuliptrees. Heading up a gradual slope, it would then cross the extension of Stone Fence Road, parallel behind Club Lane and eventually cross Crest Avenue. This was the highest point of the trail that would then bend to the right and begin a steady descent along a wider, dirt road beside a power line. This portion of the trail ran underneath mature trees with large rocks and boulders on the northwestern side. The trail terminated on Chestnut Avenue at the northern end of Seney Drive where one could see the Marion T. Bedwell School a short distance ahead on the left. I remember this trail in all seasons—rain, snow and sunshine—but my fondest memories are walking the trail with my mother on spring mornings and afternoons as she led me to and from school. Although I did not appreciate them fully at the time, they were sweet journeys.

Paths

If roads and trails act as arteries of travel and transportation, then the herd paths and footpaths were the capillaries of our neighborhood. While they may have seemed inconspicuous and haphazard to the untrained eye, the children of Somersetin knew them well.

Several small paths led throughout the Woods. Spreading out like a maze, they could take a young traveler to many important locations. One such place was called the "Old Oak Tree with the Big Leaves." It sat in the middle of the Woods and literally had leaves the size of a child's head. One might also be led to a group of large vines that we used to swing and climb.

Garden path behind The Maples.

Uphill or downhill, to the Sand Pit or down to the stream below our driveway, we were free to choose our way. One particular little path led to a pair of maple trees that sat in a modest clearing in the Woods just north and opposite our house. It was a favorite place of mine to sit and think, or hold secret meetings with friends.

My parents never worried about where I was. The wooded areas around our home were an extension of our yard. Besides, my parents had a unique manner of calling me home, and when I was needed for dinner or some other reason, a loud and nasal-sounding device fashioned out of a bull's horn was blown. I got conditioned to the sound of this obnoxious "instrument," so that it would catch my attention wherever I might be, as long as I was within a quarter mile of the house. When I heard it, I shouted an acknowledgement and scampered home. It was a very good system, I must say.

Other paths led down our side yard toward Lloyd Road, through the forsythia bushes, toward the Feldmann house and up to the chicken coop. Saving time and effort, these footpaths came in handy if caught in a downpour or if I was late for dinner, and any child could navigate them day or night without incident.

Somerset Inn School

Just below the second pond and in the area between the stream and the road are the remains of the foundation to the Somerset Inn School. The site is now vastly overgrown with trees, spicebush, barberry and skunk cabbage, but my godfather, Bill Feldmann, and his son, Richard, remember seeing the foundation of the former structure many years ago and learning of its scholastic use from a neighbor.

Mr. Evander H. Schley became the operator of the Somerset Inn following the death of Mr. Seney on April 11, 1893. At the request of his employees, Mr. Schley and the Somerset Land Company converted an ice house on the grounds into a schoolroom in 1893. This school served the children of the Somerset Inn employees and surrounding families. Apparently, all expenses were paid for the first year, including the salary of the first teacher, Miss Gent. After this, it was taken over by the township, and the school was moved to the Lloyd Road site. Subsequent teachers included Miss Hastings, Miss Martha Dobbs, Miss Marjorie Dunham and Miss Rachel Folsom. The school was heated by means of a wood-burning, pot-bellied stove, for which, I'm sure, the pupils helped to carry wood. Although the Somerset Inn was destroyed by fire on May 6, 1908, this one-room school continued

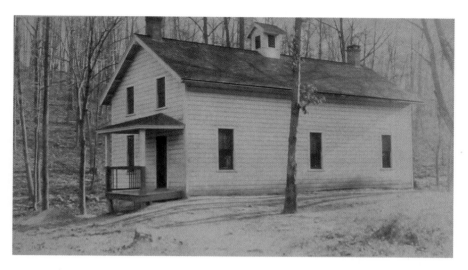

Vintage photograph of the Somerset Inn School.

until June 1910. Afterward, the building was used as a Sunday school, where services were conducted by the Reverend Thomas A. Conover, until it was dismantled between 1917 and 1920 and the materials sold.

A number of years ago, I had the pleasure and honor of befriending a gentleman by the name of Louis Starr who had also spent part of his own childhood in the area. Louis, it seemed, used to live with his family on land his family purchased in 1902 next to the old Somerset Inn, and he vividly remembers traveling in a two-wheeled horse and buggy to a school on Lloyd Road. After some checking, I determined that he must have attended the Somerset Inn School. Louis's buggy ride took him southeast down Mendham Road and left onto Washington Corner Road, which was then called Washington School House Road. At the base of the hill, the horse and buggy turned right onto a wagon road, once called Valley Road, that led past the old connection with Washington Corner Road on its left, through a wooded valley and along the shoulder of a hill to a spot directly below the pond and across from the schoolhouse. Actually, most of the bed of this wagon road still exists, but it has been used as little more than a bridle path during my lifetime.

When I told Louis that pieces of the foundation of his old school still remained to be seen, he had to go. He and I did visit the site one sunny afternoon in 1997, and he confirmed that this was the place where he once attended classes as a very young boy. This was the first time he had been back to the site, and the sense of history that flashed before both of our eyes was incredible. We both shook our heads with amazement as I helped him

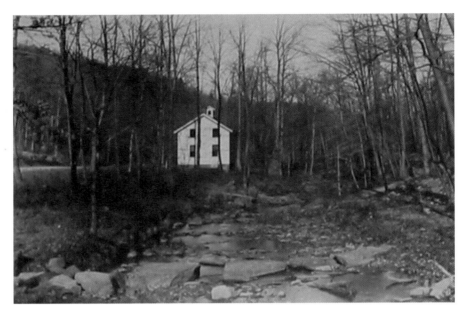

Vintage photograph of the Somerset Inn School looking northeast from the brook.

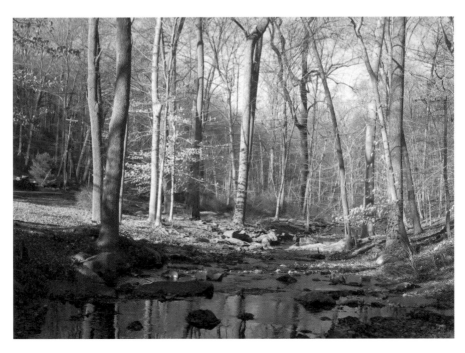

Current view of the Somerset Inn School site looking northeast from the brook.

through the tangled undergrowth to inspect the crumbling foundation and the remains of a cistern. After several minutes, we took our leave, but not before I was able to present him with a hand-sized portion of one of the foundation stones that I was able to salvage as a memento. His eyes and the stone, both dark and glittering, told a similar story of strong beginnings and a life well-lived. Louis clutched the stone as we drove home, and I came to understand that the fragment of rock that lay in his lap represented not only a foundation for a building, but a foundation for his own life and all of the lives of friends that crossed this school's threshold and had dispersed to spin out their time into eternity.

Wild Inhabitants

All things bright and beautiful,
All creatures great and small,
All things wise and wonderful,
The Lord God made them all.

—Cecil Frances Alexander, "Maker of Heaven and Earth"

Fishing at the Old Lloyd Pond

Water draws young children like iron to a magnet, and it was often that I would make the trek through the Woods or down the road to the water's edge. A good portion of the time I had my fishing rod in tow. When I was a child, the old Lloyd pond was known as Van Rensselaer's Pond, as this was the property owner's name at the time, and it was the destination of choice for neighborhood anglers.

In my younger years, and often after dinner, my father would pack my brother and me up in our family's station wagon, head down our driveway, grinding over the crushed stones and dirt and kicking up a cloud of dust behind us, drive the short distance down the black macadam road and park close to the dam under a line of trees. Assembling our gear was somewhat of a production, and each of us would scurry to our favorite spot to fish—a piece of territory that we thought brought us the most luck, although there was a good deal of wandering that took place. Standing near the road on the edge of the pond in the early evening, we would make cast after cast into the dark water, hoping for a strike. We could usually count on catching Pumpkinseeds or Bluegills, but once in a while one of us would pull in a Largemouth Bass.

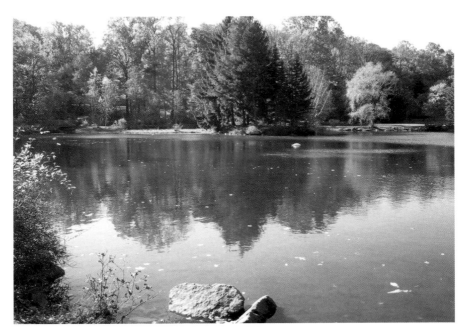

Current view of the Old Lloyd Pond from the road.

Vintage photograph of the dam.

I remember how the lure made that satisfying "plunk" sound as it hit the water, followed by the clicking of the reel when I brought in the line. There is also that sweet feeling of anticipation I recall while watching the bobber for any sign of a strike, and there often seemed to be a powder-blue dragonfly that would set upon the tip of my rod in between casts, its transparent, white and black banded wings lowering and settling in several stages before coming completely to rest at a horizontal position.

If one lure did not seem to be doing the job, there was a multitude of choices waiting in the tackle box. Spoons and spinners, corks with hooks in them and rubber worms and frogs all mixed together. The bottom of the box held rusted hooks and discarded line that was too knotted to have any chance of ever being untangled, and all the tackle was permeated with the smell of salmon eggs, which were often used for bait.

Hovering in the water were scores of male Bluegills, each guarding their circular nests and chasing other fish away if they got too close. The sights and sounds of herons, ducks and geese graced the shoreline, and a pair of white swans disturbed the glassy surface of the water as they glided across the pond, often in pursuit of the Canada Geese. All of this was embraced by the continual chorus of water cascading over the dam, and as twilight approached, muting the colors and cooling the air, it became easy to drift off into a relaxed and peaceful trance. It is a peculiar state of mind that brings fishermen back time and again to feel a part of something greater than the self.

However, I think the strong tug on the line is the part about fishing that becomes most addictive. It is the unseen force, the unknown aspect that injects a sense of enchantment into the sport. Up from the depths comes a creature that is not as commonly seen as are, perhaps, the deer, squirrels and other land animals. You get to absorb the fish's frantic bid for freedom while it fights on the end of the line, haul it up on the shore, touch the gleaming, slippery scales, see the gaping mouth and feel the strength in its flopping body. Just before release there is a sense of potential energy that culminates in a sudden flash of power as the fish dashes for the cover and safety of the pond's depths.

It is magic, in a way. It's a communion between man and nature, a gift that is relived time and time again in a young child, and if one is lucky, remains to be savored as an adult. Indeed, I have derived a great deal of pleasure in creating similar experiences at this same fishing spot with my son, establishing a connection through time between him and the grandfather he never got the opportunity to meet.

Of course, there were long waits in between catches and many frustrating moments. Errant casts often reeled in branches, algae and pond grass more

Current view of the dam.

often than fish. But these experiences went with the territory. They were expected, and no one seemed to mind them very much. When lines or hooks became hopelessly tangled or snagged, the lines were cut, and a new hook or lure was attached. We continued undaunted because, deep down, we all knew that the next cast would surely land the big one. Right?

Cows on the Loose

The Rankins kept a small herd of cows in their pasture that bordered the top end of Lloyd Road. Many times my father would pull our car over to the side of Lloyd Road to give me the chance to feed them handfuls of long grass or just watch as they grazed. It was a common sound to hear their low moos echoing across the neighborhood, a sound that I appreciate now more than I did at the time. On occasion there were escapes, and one of the Rankins would need to retrieve their bovine trespasser and lead it back to captivity. Most of the time, they never got far from the pasture before they were noticed.

On one particular afternoon I heard a bell in our front yard and looked out of our window to see a cow grazing on our lawn. What a surprising sight that was! I thought about how one might go about leading a cow back to

pasture if it didn't want to go because this cow was about as complacent an animal as one could expect to find. Being used to people, it was not easily impressed by hand-waving, shooing adults—and, hey, who's going to argue with something as big as a cow? The Rankins were eventually telephoned, and two adults showed up in our yard to lead the cow back home.

Well, sitting on our front porch, this endeavor proved to be pretty good entertainment for the better part of an hour. One person attached a red lead to the cow and pulled while the other pushed and provided incentive by means of wielding a large stick. I guess the grass must have been greener on our side of the fence because that cow took its time in moving. Eventually, however, the cow decided it was time to move on and fairly ran back toward the Rankin property, probably eager to tell her barn companions the tale of life on the outside.

WILLIE

Some families, like the Feldmanns, had cats, many families had dogs, but we had a tortoise. Yep, a real, live gopher tortoise, whose name was Willie, with yellowish markings on its dark brown shell. Willie was a gift to me from my father who taught botanical and biological sciences at Fairleigh Dickinson University. Now, I have to admit that there are not many tricks a tortoise can do, and he was not much good at retrieving or snuggling in my lap, but he was cute in his own way.

We kept him in a sand-filled aquarium in our dining room, and on sunny days my grandmother would take him outside and let him walk among the weeds that grew at the edge of our driveway while she sunned herself. On several occasions Willie would get lost—or I should say, we lost him—and a frantic search began among the weeds and myrtle bed to find him. He was always found, but one day my grandmother wanted to be sure he didn't get away again, so she tied a string around the middle of his shell and wrapped the opposite end around her finger. This allowed her to sit peacefully in the sun while Willie went about his business. Eating wild plants, lettuce and other vegetable matter, he was easy to care for, but the sight of an elderly woman walking a tortoise on a string was an extraordinary sight to behold!

FLASHLIGHT TAG AND FIREFLIES

Whether it was from a slight fear of the dark as a child, the lure of the unknown, the surrounding night sounds, or our imaginations, the evening

hours always held a special attraction for me. The gathering darkness brought with it new types of adventures and an air of fantasy that was much different from daylight. Evening recreation time was spent at either my house or the Feldmanns'. Scampering, laughing children ran through the lawn, soaking their shoes in the newly formed dew while the adults talked and sipped cold drinks on the patio.

During the warmer months when we could gather a group of four or five of us together, my friends and I enjoyed playing Flashlight Tag—and a challenging game it was! These games lasted a good, long time due to the multitude of excellent hiding spots in our yards. One had to look very carefully and in all sorts of places: wood piles, behind hedges, up in the branches of apple trees, underneath porches. The possibilities seemed endless, and one was free to change hiding locations during the game as well. Looking back, there was a pretty stiff sense of competition during these games because we wanted to find *the best* spot to hide, and having been discovered in earlier games, the pressure to conceal oneself increased with each round. Often our flashlight batteries gave out before we did.

Fireflies, or lightning bugs as we most often referred to them, are a special favorite of mine to watch on summer nights, and doing so always has the ability to transport me back to my evenings as a child. Catching them takes keen eyesight and quick hands, something most children come by naturally. My yard was perfect for this activity due to the woods that surrounded my home and the longer grass on our property.

A vigil would begin just after sunset, and after about twenty minutes, a few flickering lights would be spotted in the darker shadows on the edges of the yard. In the illumination of twilight, increasing numbers would appear, rising up out of the grass, doing their nocturnal dance until hundreds of these creatures could be seen putting on a spectacular performance.

Armed with kitchen strainers and mayonnaise jars filled with handfuls of grass, my friends and I would scatter over the yard being drawn in myriad directions in the cooling atmosphere of the night. Large and small flickers would be collected with choppy swipes through the air, and upon inspection of the strainers, the firefly harvest would be tapped lightly into a jar.

We often lost track of time, and when it was time to go inside the house, our jars would be crawling with sparkling lightning bugs. My favorite thing to do was take them to my room when it was time for bed. After my light was out, I would give the jar a little shake, which seemed to excite the fireflies and increase their flashing. Letting twenty minutes or so pass, I would open my window, gently set the jar on the roof outside my room and remove the top. Lying inside with my head on my pillow, I would fall asleep watching their escape. Light after light trailed up and out of the jar as each

firefly found freedom, dancing off into the night sky like blinking fairies and leaving me to sleep and dream.

Pellet Guns and Bees' Nests

Warm summer afternoons and evenings would often find Rich and me cooling off with an orange Popsicle on his back patio. Above us we would occasionally notice paper wasp nests under the soffits of his house. Who knows why, perhaps it was an inherent sense of mischief, but those that seemed to be more than four inches in diameter were irresistible for two boys.

Mr. Feldmann had a very accurate, air powered, pellet pistol that he would allow us to use for target practice. Usually we would aim at cans that we lined up in the yard, but given the chance, we would go for the wasps. The nests were usually high up at the peak of the house, so there was little chance of hitting windows and the like with the pellets. Backing off under the birch tree that grew at the corner of the patio, Rich and I would take turns pumping the pistol and pulling off shots. I must say our aim was rather good, and it was fun for us to see the increased and wild activity around the nest as a result of our direct hits.

Of course, our efforts sometimes led to pieces of the nests being torn off and falling to the patio, carrying a host of angry wasps in tow, but these were efficiently remedied with a can of flying insect spray. In hindsight, this was not the safest activity in which to engage, but at the time, we considered it entertainment of the highest order.

Birds and Windows

Some of my earliest encounters with nature occurred due to the misfortune of some local birds. Our double garage doors had a row of windows that ran across the top of them. While they provided a good view from within, they were a bit like mirrors to birds on the wing.

Numerous times our days would be interrupted by the telltale thump of a bird flying directly into one of the panes. Of course, this would send me scurrying to investigate. A few would simply fly away and be gone by the time I arrived on the scene. Sometimes their necks would be snapped by the impact, and they would meet with a painless, instant death. Others were not so lucky and suffered before passing away. However, there were the fortunate few that, although stunned, recovered quite nicely. Cradling

The author and one of his bird rescues.

them in my cupped hands, my father taught me not to hold too tightly, and I would offer them water and stroke them on the back. In time they would regain their senses and muster the strength to stand. Having a wild bird in your hands as a young boy is an enchanting experience. Their little feet and nails feel odd on your skin, and their hearts race with shock and fright.

Eventually the grand moment would come, and the birds would lift off and fly away into the woods. The whole experience always left me with a profound sense of connection with the natural world.

DUSTY

The wildlife in the area was, and still is, abundant. Deer, squirrels, opossums, foxes, a variety of birds and other creatures were common sights and expectations. One day, Rich discovered an orphaned baby raccoon in the storm drain on the side of Lloyd Road, the baby's mother having been killed on the road. After some persuasive pleading, Rich's parents decided to let him raise the raccoon as a pet. Betty Feldmann even placed a call to Sterling North, who lived a couple of miles away on Jockey Hollow Road, to get tips on caring for the young raccoon. North is the author of the 1964 Newberry Honor award winning book *Rascal*, and his book tells the tale

One of Dusty's descendants?

of his boyhood adventures with his pet raccoon. North's advice included having the baby raccoon sleep with a towel-wrapped clock, which calmed the kit by simulating the heartbeat of the mother. Thankfully, all went well, and the little raccoon thrived. In time, her name came to be Dusty because of the raccoon's persistent habit of sticking her nose into seldom vacuumed corners of the house, which resulted in her snout being covered with balls of dust. Dusty had the run of the home and was kept indoors until her size and habits necessitated a move to an outdoor cage.

While she was comical to watch, she had very sharp teeth that had to be respected. Rich was nipped more than once by the needle-like chompers. I remember watching her wash almost everything she ate, an instinctual raccoon behavior, in her water bowl. One of her favorite, albeit annoying, delights was unraveling entire rolls of bathroom tissue with her dexterous front paws and trailing it around the house like crepe paper—much to the dismay of the Feldmann family. At another point she got into the bottom cupboard to the right of the kitchen sink where the liquor was stored. Reveling in an impromptu happy hour, the little raccoon managed to open a bottle of crème de menthe and lap up a good deal of the green liquor. The result? Dusty became more than a bit tipsy and was, I'm sorry to say, a nasty drunk, snarling at anyone who dared to disturb her revelry until she slept it off in a corner. However, most times she did very well as a pet, often hitching a ride on Rich's shoulders or head, and the bond between Rich and Dusty developed into a strong and trusting relationship.

Dusty was even entered into a pet show at the Kiwanis Fair, which was held every Labor Day weekend and one town away at the Oak Street School in Basking Ridge, New Jersey. However, for some reason Rich was not at the show ring when it was Dusty's turn to enter the circle. Filling in, Rich's mother, Betty, assumed the role of handler, and both she and the raccoon entered the ring as a pair. Now, Dusty was not your usual pet, and true to form, she was not content with being carried like a domesticated animal. Instead, amusing both the crowd and the judges, Dusty spent her moment in the limelight riding on Betty's shoulders and clinging to the top of her head like a coonskin cap. Capturing the hearts and attention of everyone, the pair won first place and came away with a blue ribbon!

One day, very near Dusty's first birthday, the call of the woods and the need to find a mate became too strong for the now very substantial-sized raccoon to ignore, and she found a way to escape from her outdoor cage. Needless to say, we were all sad to find her gone, but the story has a happy addendum. Several months later, Bill was outside in the driveway, working on the family car at dusk when he felt something nudge his leg. Looking down he saw Dusty, but she was not alone. Apparently, Dusty had become a proud

mother and had come to brag, for there, following behind her, were three kits. Well, Betty wasted no time in supplying the new mother and her family with her own version of a catered baby shower by placing several pieces of peanut buttered bread and red and white star mints on the back patio.

Dusty's display of her kits was the last time the raccoon was to be seen by the Feldmanns, but fate had one more meeting in store for Rich. The woods were a favorite place for playing, and one day Rich related a wonderful story to us all. It seems that he was hiking though the woods after Dusty's last appearance when he was quite startled by an animal jumping on his back from a tree limb above his head. It was Dusty! Whether by sight or scent, the raccoon had remembered her former adoptive human parent and decided to quite literally drop in for a visit. Although this was to be the final time that the two got to see each other, it provided a chance for them both to say goodbye before Dusty scampered off into the surrounding woods, her ringed tail disappearing under a wild raspberry thicket.

SKIPPER

Across the road from the end of our gravel driveway is a house and property that used to be patrolled by a Golden Labrador Retriever named Skipper. This dog had a protective instinct that was unmatched by any other dog in the neighborhood, and it was extremely rare that anyone could pass by his owner's stretch of property along Lloyd Road without being charged by this frightful canine. Although augmented, no doubt, by a child's imagination, it seemed as though he spent his days lurking along the fringes of the house shrubbery, some forty yards from the road, waiting for anything or anyone that would dare enter into the attack zone.

At times there was no escaping this route, especially if one were sent to gather the mail as I often was, and it became a sly, evasive game of cat and mouse, or dog and human as the case was, to see if Skipper could be avoided. When he did charge, there was plenty of warning. His deep barks and growls began at the house and continued as he shot down the hill, across the lawn, through the weeds and onto the road. While this was happening, I remember an intense fear welling up in my chest, followed immediately by a blast of adrenaline, which propelled me, faster than I ever recall being able to run, down my driveway. At times, mail would fall out from under my arm, but I certainly did not care to stop. I thought of the letters as being an appetizer, and I was not going to stick around to be the blue plate special.

Typically, in a schizophrenic manner, Skipper was more mild-mannered when his owners or their children were present, and there were many

occasions when I was invited over to play and got on rather well with ol' Skipper. At times like these, or when no one else appeared to be in striking distance, cars were the object of the dog's aggression. Many times I remember Skipper chasing automobiles and trucks as they drove up or down the road. Often he would bite at the tires as he did to our station wagon. Most times he escaped unscathed, but on a few occasions he was not as lucky. I once saw Skipper get hit by a car while the Feldmann children and I were selling lemonade along the side of the road. It was scary, but the injuries were not life threatening. You would think that the dog would learn its lesson after a few lip locks on a bumper, but it never seemed to faze Skipper, and he always recovered and resumed his chasing with renewed vigor.

In 1996 I had an opportunity to stroll down Lloyd Road for the first time since 1983. As you can imagine, a flood of memories came pouring through my mind, but as I made my way past the end of my former driveway, only one memory pervaded...Skipper. No sooner had the thought of the dog crossed my mind than a pair of barks and growls were heard, and I looked to see two Golden Labs careening across the grass toward me. Could it be? Impossible! Of course it wasn't the infamous dog himself. Alas, even Skipper could not cheat death after twenty-six years, and it proved to be two faithful pups carrying on the tradition of chasing anything that moved. The only difference, much to my delight, and that of the current neighborhood children I'm sure, was that the dogs advanced only so far before being stopped abruptly by an invisible fence system. For a moment I had the gift of being emotionally propelled back to 1969. The fight-or-flight response had kicked into action, and I had to chuckle to myself as I thought of at least one event from my memory that was being perpetuated.

Trapping

When I was about seven years old, I had a mole removed from my chest. The procedure was done in the hospital, and it scared me to death. To reward me for my bravery, my father presented me with a small Havahart animal trap when we left the hospital. The trap was large enough to catch chipmunks and small squirrels, and would not harm the animals. I was enchanted with the thought of getting very close to animals, and set about catching them almost immediately.

I was pretty good about picking locations. The first order of business was to find an animal path in the field grasses or the undergrowth in the woods. This assured me that there would be sufficient animal traffic to give me a good chance for a capture. Usually I would find a suitable spot down in the

field by the Sand Pit, up near the dilapidated Lloyd chicken coop above our garage, or back in the Woods next to our driveway.

The next procedure was to bait the trap. My favorite bait was peanut buttered bread, which I would carefully balance on the trip plate in the middle of the trap. After setting the trip plate and the locks on the cage doors, it was ready to go. Mornings were my favorite time to set the trap, and I would go back to check on it several times a day. My success rate was about fifty percent, and all animals were quickly released.

I even used a very small Havahart trap to catch mice in our home, and if there was ever a score to be settled on the part of the neighborhood fauna, it found its champion in the form of one particular, White-footed Mouse. One autumn afternoon I discovered a mouse in my trap in my family's basement, and I immediately set out to release him. Choosing a location in tall grass and underneath one of our apple trees, the fruit of which, I presumed, would provide a source of food. I opened one end of the trap and waited for the mouse to run into the grass. The captive didn't budge. I thought it best to give it some gentle encouragement by shaking the trap in an effort to dislodge the reluctant rodent. I shook and shook and shook, and the technique finally produced the desired result, but it also brought a surprise. The mouse, after being held against its will in the trap for a couple of hours, shaken free of its hold, free-falling several feet to the grass and landing in an unknown environment, immediately, and with one hop, sought the protection of the nearest shelter—the pant leg of my jeans! Let me tell you, the surprise and sensation of a frightened, live mouse squirming up your pants as a young boy is a singularly unsettling experience, and I must have been quite a sight, jumping, yelling and batting my leg. In a short time, the mouse was dislodged. It hopped off into the grass, and I vowed never to shake a mouse from the trap ever again!

Larry, one of the older boys in the neighborhood, also liked to study animals, and he often took me out to set larger Havahart traps for raccoons and opossums. Our favorite location was under the large tree that grew in the center of the meadow where Winding Way Road now exists. Other times we would select a spot up on the hill in the woods across Lloyd Road and opposite the lower pond. The bait was the same, except for an occasional apple that we would throw in to sweeten the pot a little bit.

There was one potential problem, however. Our ability to capture larger animals also meant we could catch skunks, and nobody wanted to get that close to one of these creatures. As a safety precaution, we developed an elaborate means of opening the trap with strings in order to release the animals. Long lengths of string would be tied to the locking wires and doors, and extended up and over tree limbs and out to a spot where we could view the trap from

Lloyd Bridge as seen from the dam.

a safe distance of about thirty feet. By pulling the strings we could unlock the traps and raise the doors without setting foot near the animals. This worked well for all animals since we could not always predict what a captured animal would do upon release. Only once did we catch a skunk, and believe me, we could smell it long before we got to the trap. Thankfully, all the strings worked, and the skunk was released without incident.

Our catch record was pretty good, and we fancied ourselves quite the woodsmen. No animals were ever harmed, and times being what they were, I received a great education in the behaviors of certain animals. I knew the environments and locations that the animals favored, the foods they would eat, the times of day that they were most active and even became familiar with individual animals that were caught more than once. In a roundabout way, trapping developed a deeper respect for the animals as individual creatures and increased the bond between the environment and me around my home.

Catching Crayfish

One of the more challenging stream sports was catching crayfish. These little creatures resembling lobsters were quicker than most little hands—

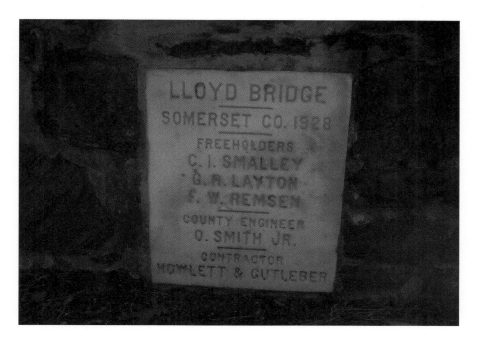

Lloyd Bridge credits.

human or raccoon. This was fortunate for the crayfish, because we would have wiped out the population for good had it been otherwise. Most of the time they could be found underneath rocks at the bottom of the stream, but you couldn't just pull rocks up in a carefree manner and expect to find these critters. *Au contraire*! The task involved much more finesse. Any quick movements sent the crayfish scooting off backwards into a new hiding place. It was a delicate maneuver to dislodge the rocks, and it had to be done without causing the silt and other stream bed material to cloud the water. Of course, this meant that your feet had to be downstream from the search site so as not to degrade the clarity of the water.

Assuming you lifted the rock cleanly, and this took practice, one had a short time in which to scan the streambed for any crayfish, which hated being left exposed. Spotting them was tricky, because their coloring blended in very well with the surrounding pebbles and silt. They also came in a variety of sizes, from one-half inch to upwards of three inches, so one was sometimes looking for pretty small animals.

Once spotted, crayfish had to be scooped up from behind, since that's the direction in which they would try to make their escape. Usually the scoop came up empty, but every once in a while there would be success. The hand was the preferred scooping tool, but one had to be careful with the bigger

Crossing stones in the stream.

crayfish. The larger the crayfish, the larger its claws, and the large ones could give quite a mean pinch! Held from the tail section, however, they were harmless and could be placed in a water-filled pail for observation.

Raccoons loved to eat these delicacies, and I'm not surprised since they're so similar to lobster. Their fate, however, was much less serious in my hands. Most of the time their captivity lasted all of ten minutes, and then they were spilled back into the stream where these little crustaceans lived to pinch another day.

BRIDGE WADING

Below the dam on Van Rensselaer's Pond, the stream ran under the first of three bridges on Lloyd Road, aptly named Lloyd Bridge. This shaded area was a haven for fish that we called suckers. Suckers were bottom feeders that were extremely hard to catch with lures, or worms for that matter. They had whiskers and a circular mouth underneath the tip of their heads, and they were about the ugliest fish one could hope to pull out of the Somersetin streams or ponds. However, their size could be impressive.

Some were well over a foot in length, which, of course, seemed even larger to us at the time.

Rich and I would go to the bridge on missions to catch these fish, employing a highly sophisticated and quite cooperative method. Donning green, lace-up, rubber boots, one of us would herd the sucker fish toward a net or bucket held by the other. I suppose if one were to watch this from afar, one might be challenged to determine who had the higher intelligence, the fish or us. But, hey, it was all in the name of fun. Forget about dry feet, because the boots got wet after the first "herding," and believe me, water filled boots can be hard to maneuver. Between the splashing, slipping and shouts of frustrated laughter, it's a wonder we caught anything at all. But sometimes we got lucky, and I'm sure that luck was all it was. You'd think we'd hit the lottery by the joyous sounds that sprang from our lips when a fish was captured. Of course, capture meant examination, and the fish managed to capture our attention for perhaps thirty seconds before wriggling out of our clutches to fall back into the stream. But we didn't mind the escape. We were victorious!

If fishing under the bridge grew tiresome, there were other things to do as well. Just downstream from the bridge is a series of large, flat rocks that provides a natural crossing. Large enough for an adult to sit upon comfortably, these rocks were fine for stretching out in the sun, or for sitting and watching the flow around the other stones in the stream bed. The bubbling sound of the water was hypnotic and intoxicating. So much so that the world seemed unusually quiet after I emerged from the stream and climbed back up on the road.

Sometimes, if I were feeling fanciful and creative, I would construct little boats out of sticks and leaves and float them downstream just to watch their progress. Often I would follow and rescue them from eddies along the way, but mostly I sat and tracked their courses until they were demolished by a tiny rapid, or disappeared out of view around the bend in the stream where the old Somerset Inn School used to stand.

6

Around the Seasons

At Christmas I no more desire a rose
Than wish a snow in May's new-fangled mirth;
But like of each thing that in season grows.

—William Shakespeare, *Love's Labour's Lost*

SLEDDING

Winter meant lots of things to me as a child, such as snow days off from school, building snowmen and skating, but perhaps the most cherished activity of all was sledding. There existed within our neighborhood a multitude of snow-laden hills on which to glide. There was the hill on our front yard that led down toward Lloyd Road and the Packards' yard, and in addition, there were the short and long sledding courses, which ran across our back yard and down through the old orchard.

One of the most memorable sledding runs I have had occurred after a series of thaws and hard freezes over a foot of snow. The air was crisp and could almost rob a person of his or her breath on the morning I carried my sled to the top of the hill behind our garage. Dressed for speed in my blue snowsuit, although on the pudgy side, I was ready for action. The runners on my Flexible Flyer sled were steel-wooled and waxed to perfection, and I was proud of my sled's performance. It was, in my estimation, a finely tuned machine that offered me thrills and the exhilaration of controlled speed. Our driveway had just enough snow and ice remaining on it to provide a route between the incline behind the garage and our yard, which led into our neighbor's property. Their yard used to be the old orchard, but very

Snow-laden daffodils.

few trees remained. Instead, it offered an ever increasing grade down to the small stream that passed under Gordon's Lane.

I knew the run would be slick, but I was not aware of just how fast it would be. This was one of those times when a child could walk on top of the snow without breaking the icy crust. Struggling to the top of the hill by the old cherry tree, puffing my breath into the air like a steam engine, I positioned myself headfirst and belly down on my sled, pointed my runners downhill and pushed off. Almost immediately, I discovered that I had little or no control of the sled, but I didn't worry. The driveway flattened out and gave my runners a better grip. Rounding the Double Oak tree in our parking area, I steered to my right and down the hill, expecting to surely sink through the crust. No chance! My sled picked up speed instantly, sending a thrill through my body as I narrowly evaded trees by steering with my sled and my feet.

When I reached our neighbor's yard, the sunlight reflected brightly off of the hard, glazed surface. I think it was about halfway down the hill that I began to become concerned about how to stop before hurtling down the final embankment and into the stream. Although the following events happened in a matter of seconds, I can still remember the time stretching out before me as I contemplated my choices and the fast approaching tree line above the stream. Option one: foot dragging. No good. Try as I might, I couldn't break the surface of the ice-crusted snow with my toes. Option two: steer out and away from the stream. Not knowing about the effects of steering on ice, I cut hard to my left. In a flash, my sled and I were thrown into a wild, rotational spin that hadn't changed my direction one bit. Fantasies of fighter pilots and race car drivers filled my imagination. Option three was fast approaching: bail out! I remember feeling a twinge of guilt—a captain abandoning his ship in the face of oncoming disaster—but, oh hell, I was nine years old. Off I rolled, trying comically to control my spinning in my blue nylon overstuffed snowsuit. I did, however, manage to slow myself enough to witness the sudden demise of my chariot. With a crack that is still audible in my memory, my Flexible Flyer struck a large tree, flipped twice and plunged down and over the embankment. The act of retrieving the remains presented the horrible sight of broken wood and the apparent end of a fine sled, yet I faced this situation like any young boy would have done—with the incredible urge to do it again!

The most famous hill in our area was in the Packards' back yard. The Packard family lived in a low white house on a piece of property that filled in the gap between the Feldmanns' back yard and our property, occupying the space where the Lloyd Estate's Bottom Kennel and the pigpens used to stand. Most of the Packards' rear property consisted of a hill unobstructed

by trees, shrubs and fences. It was perfect for sledding, and seemed to draw young and old alike who wanted to get a taste of speed and excitement. Of course, there were certain unwritten rules and procedures that needed to be followed when one went sledding. First, there was the time honored tradition of *never* setting foot on the actual sled or toboggan track. Those who did drew immediate chastising from the other sledders and might be pummeled with snowballs if the offense were judged to be serious enough. Second, it was expected that anyone wanting to toboggan had to put in their share of time building and maintaining the jumps, sometimes built to spine crushing proportions. Third was the cardinal rule that sleds were not permitted on toboggan courses, lest the runners cut into and destroy the compacted surface of the course. Fourth and last was the logistical rule that, simply put, stated, "If you rode it down, you pull it up."

Sledding was an all day activity on weekends that even extended into the evening. By ten in the morning there would be up to a dozen of us on the hill looking to get the best slide for our efforts. By evening we were cold and exhausted, having consumed gallons of hot chocolate or Ovaltine throughout the course of the day and had our snow clothes run through the dryer cycle sometimes three or four times. Night sledding added a heightened sense of adventure to the ride. This was due to the unseen bumps that would suddenly be felt underneath you, and the silence and peace you felt after completing a good run and you lay back in the snow with millions of stars winking back at you from the sky.

As to the tools of our trade, there were a few but nevertheless very essential items. Flexible Flyer sleds were the sport cars of the hill, able to steer around curves and other sledders, and they were the standard of our day. Many hours of my childhood must have been spent maintaining the runners with steel wool to remove rust and applying wax to guarantee a slick surface. If you had a fast sled, everyone knew it. Toboggans were the sledders' equivalent to a minivan. Holding two to six people, they took a while to gain speed, but afforded a group experience unparalleled on sleds. Toboggans had an advantage over sleds in that they could be used in deep snow. Where deep snow would engulf a sled, toboggans packed the snow underneath, and once a toboggan track was established, it got faster and faster with continued use.

Jumps, sometimes two or three on one track, were constructed out of piles of snow, and banked turns were sometimes employed as part of the design as well. On very cold days we would carry water out to the portions of the course that had turns and jumps, which we would fortify by creating a glaze of ice on their surfaces. Feeling like a bobsledder, I recall the exhilaration of steering down the hills, being thrown to one side during a turn, hitting

jumps with enough speed to launch me off the toboggan, the shock of once again making contact with the ground and then the aerodynamic tuck to get down the remaining part of the hill as far as possible. You see, the quality of a run was judged not only on how well you navigated the course but by how far you traveled as well. Wipeouts were a part of sledding that were enjoyed as much as—if not more than—successful runs. Hitting a jump or turn at the wrong angle spelled instant disaster and sent toboggan and riders either sideways or headfirst into the snow in one large heap. Laughter soon spread throughout the group as each tried to reach down their coats with frozen mittens to remove the icy snow that would collect and melt in the collars of sweaters and under untucked shirts.

SNOWBALLS

On occasion we were more mischievous in our attempts to utilize our environmental resources. On snowy winter days, after building snow forts, drinking unknown quantities of hot chocolate and bothering our parents to dry our clothes in the dryer, Rich and I would experiment with our throwing accuracy. We took great care in making the perfect snowballs, not too softly packed as to risk falling apart and not so hard that they would hurt.

After tiring of pelting each other with the cannonball-sized projectiles and scooping the melting, collected slush out of the neck openings of our coats, we set our sights on more evasive prey: the automobiles. Now, bear in mind that I do not recommend this activity, and we never did this in an aggressive manner, but in our minds at the time this opportunity was irresistible, and we went to great lengths to plan our attacks.

Ammunition needed to be manufactured to exacting standards and stockpiled behind a tree or shrub by the roadside. Snowballs had to be heavy enough to heave a good distance, but they could not have any rocks in them. I guess our consciences felt better this way because we significantly reduced our chances of damaging the cars we occasionally hit.

After we were sufficiently prepared, we sat in wait for our victims. This waiting game always seemed to be unbearably long. The cold, the lack of traffic and the anticipation often got the better of us, and skirmishes occasionally broke out between my friends and me in our individual arsenals. When a car did pass, we would take our best shots from behind our snow walls, trees, or bushes. Most times our efforts resulted in a flurry of white blobs arching across the road and over the cars, an occasional lucky shot landing on the rear trunk of a passing vehicle, the driver oblivious to what had occurred.

On one occasion when there had been a lengthy period in which no cars had passed at all, we began to hear the most sought after and cherished of all targets. It started as a low hum punctuated by periods of engine revving, gear changing and acceleration. The sound grew louder, and eventually we saw the mother of all targets, the dream of all snowball snipers—the milk truck! We couldn't believe our luck! A snowball gathered in each hand, we lay in wait for our target to pass as the driver began to slowly make his way up the hill. The excitement was almost too much to bear, but eventually the target was in front of us. The glorious moment had arrived! We let loose with an incredibly accurate barrage of snow unequaled in our short history, each shot inexplicably finding its mark.

What happened next is indelibly etched in my memory. You see, milkmen, due to the nature of their job, exit their vehicles quite often and find it quite convenient to leave their front door ajar. This one was wide open and seemed, like a black hole, to suck every snowball into its opening, splattering the driver with a surprising number of soft, white missiles. Never had we been so accurate, and I don't know who was more surprised, the driver or us.

I do know that the milkman wasted no time in stopping the truck and jumping out to investigate the source of his attack. Faced with a fight-or-flight response, we did the only thing that seemed logical to us at the time—we ran! We took flight up Rich's right-of-way like the devil himself was chasing us, which seemed not far from the truth. Upon glancing over our shoulders, we spied a terrifying sight: the milkman was in hot pursuit and churning up a fantail of snow behind him as he ran.

This time, however, youth was on our side. Using our knowledge of the area we darted down the gravel road that led to the chicken coop below the Rankin house and hid behind the shrubs. Hearts pounding, we waited to see if our pursuer would round the bend. He never did, and we finally spotted him walking back to his truck, brushing the snow from his clothing. After waiting to hear the milk truck finally moan up the remaining part of Lloyd Road, we came out of hiding, relieved at our narrow escape. I don't remember throwing any more snowballs that day, and to my knowledge, this event served to bring our sniper activity to a grinding halt.

Skating at Rankins' Pond

I learned to skate on the Rankins' Pond. It was not often that this pond froze to the point of satisfying the Rankins enough to permit skating, but every once in a while it would be open to the neighborhood, and believe

me, everyone took advantage of the opportunity. In these times liability was not at the forefront of people's minds, or if it was, it was suppressed by the wholesome aura that permeated events such as this.

It was like you might imagine it to be. There was cold air biting at our cheeks. There were neighbors with brooms clearing the ice, fathers lacing up their children's used or hand-me-down skates over triple layers of socks and scarves and gloves, moist with snow, which froze and stuck to the cold steel skate blades. I recall perpetually runny noses, and there was the promise of hot chocolate when you became too tired to skate anymore and walked home on weary ankles with your skates tied together and slung over your shoulder. It was a time for a community to join together.

I can still close my eyes and see myself on the end of the longest human whip I can remember. I struggled to hold on but eventually spun off as the others eventually did. I can hear the familiar cracking sounds of the ice that came up from underneath the frozen surface. Familiar still are the tentative first glides away from the edge of the pond and the sudden falls on my well padded rear end. Skating was a chance to mingle with the high school boys in the neighborhood, a chance to show off newly learned skills and an opportunity to laugh and shout with delight with all of my friends.

These times have mixed together into one, but they always seemed to end just as dark was descending and the sky turned still and black. Huddled next to a radiator in the Feldmanns' house or my own, the aroma of hot chocolate mingled with that of wet leather skates and wool, and I warmed my hands on the mug, thoroughly exhausted and utterly content.

I was once treated to a story from my friend Louis Starr. Being fifty-two years my senior, there were many stories that fascinated me about his early life on and around Lloyd Road, but none developed a bond like his stories of learning to skate on the Lloyd Road Pond. He was speaking of the larger one with the dam beyond our driveway, but the similarities were meaningful, for we shared the same type of experiences at the same place. This common thread reached across the years and connected us through memories of an area we both called home. It was comforting to confirm this continuum of experience, and I only hope that generations to come will have similar stories to recall of this place.

PEEPERS

My father, being a biology and botany professor, had a great interest in the outdoors. And so, when the Van Rensselaer's Pond came to be drained one spring for repairs on the dam, it opened up a world of opportunity. Spring

Peepers, a tiny species of frog, were abundant in the area and found the damp, muddy pond bottom to be extremely favorable. The pleasant peeping sounds that they made began at dusk in the spring and continued well into the night.

One evening my father asked if I would like to go with him to collect some of these little frogs at the pond. Thrilled with the prospect of accompanying my father on a scientific expedition, we set off with our boots, collecting net and large glass jar. The mud is what I most remember; mud so thick that it engulfed my feet and legs and refused to let go at some points. Luckily, my father was there to pull me free. The sucking sound upon release was compounded even more by the cooling sensation of ooze, which ran down the inside of my boots, but I loved every minute of it.

We were surrounded by a symphony of nature, and we wasted little time in scooping up the little, olive-green singers and placing them in the jar. Catching them was a little tricky, but within a half hour we had several fine specimens safely stored away beneath the metal lid into which we had punched several air holes.

It grew dark rather rapidly, and I didn't get to inspect the frogs until we were home and under the fluorescent light of our kitchen. It was amazing to see the frogs clinging to the sides of the glass. Tiny pads on the ends of their toes allowed them to climb with ease, and I sat for a good, long time watching their movements and the rhythmic ballooning of their throats as they breathed.

Eventually it was time for me to go to bed. As a special reward, I was allowed to bring the jar into my room. There in the dark, after several minutes, the tiny frogs began to sing. Their intermittent peeps mingled with the steady songs of their kin, which I could hear through my window from outside. This is how I fell asleep that night, and it is one of the sounds I most associate with Somersetin.

The next morning the jar was gone. My father released the frogs sometime after I had fallen asleep, which made me happy. They were back where they belonged, singing for a mate. But I had received a wonderful gift, and I still cherish the sound of their lullaby.

FLORAL SCENTS

There are few things in this world that can jog one's memory as much as certain scents. One whiff is all that is needed to immediately transport a person back to an earlier specific time and place, and when this happens, the memories come rushing back as fresh as today's thoughts. For me the scents

of flowering privet hedges, wild phlox, lilac and wild roses are extremely powerful and meaningful.

On the southern end of our porch were several enormous lilac bushes that helped to provide shade but also bloomed every May with the most spectacular clumps of violet blooms. Cuttings made their way to our tables, neighbors' homes and the desks of every teacher I had in elementary school. I remember these bushes dominating the area with their exquisite scent that swept inside the house with everyone who passed in and out of the front door. Not to be upstaged by the fragrance, swallowtail and fritillary butterflies danced among the mounds of petals and bright green leaves in a brilliant choreographed display of color, which I delighted in watching. Lilacs invoke this image every time I smell them and always act as a harbinger of summer.

The hedges that ran across the hill at the top of our front yard were fifteen to twenty feet tall. Although overgrown, they bore copious clusters of white fragrant flowers each summer, which in turn attracted scores of butterflies. The heady scent would fill my nostrils while the colorful insects danced around my head. More potent in fragrance than any other flower in bloom at the time, the glorious smell literally filled the area and made an indelible imprint on my memory.

Just behind the hedges lay the property that led up to one of the old chicken coops. This area was dotted with Ailanthus trees, but underneath them grew a thick carpet of wild phlox. Blooming in the height of summer, the blue, pink and white flowers filled the air with a perfume that hovered around me as I waded through them. Their scent was attractive to other creatures as well. Bees buzzed their way from clump to clump amidst hummingbird moths, all competing for nectar and all unknowingly playing their roles in the pollination process.

On the fringes of our side yard, which faced down the hill toward Lloyd Road, was another fragrance that came to represent summer. Enormous clumps of wild roses grew up and around other trees, choking out raspberry and other smaller plants. Often interspersed with honeysuckle, the roses had a sweet smell that attracted more bees than the phlox, and the blooms remained fresh for days until the petals eventually dropped delicately to the ground.

When it was very hot, we would turn the attic fan on in our house, and a strong breeze would be pulled in through the doors and windows. Although the fan was run to reduce the heat, it also drew all of the floral fragrances into our home, mixing each scent into an exquisite potpourri. Of course, if one were lying on a bed by one of the open windows taking a nap, it was all the better.

Female Tiger Swallowtail butterfly.

Butterflies

The combination of our environment, my father's occupation as a botany professor and my interest in nature meant that a great deal of my time was spent out of doors. One of my most beloved activities was collecting butterflies and moths. I was totally absorbed and fascinated by their colors, flight and metamorphosis. The challenge of catching them was also an addictive part of the hobby. Looking back on the activity from a more modern perspective, it was rather unnecessary to kill so many of these beautiful creatures. A good number of them were mounted in cigar boxes or framed and displayed on the wall, but many ended up being discarded.

The equipment we used was rather simple and consisted of a good net, supplied by my father from one of his biological supply catalogs, a trusty field guide and a killing jar. Today, all that remains of my equipment is my field guide, but I can still remember my net feeling as comfortable in my hands as my baseball bat and glove. Rips, tears and holes were commonplace and a consequence of swiping specimens from blackberry thickets, but damaged netting was easily replaced by sliding a steel collar down the handle, releasing the metal hoop from its inset grooves, removing the ripped net for repair and rethreading the new one in its place. This method insured there was always a reserve net, and I needed it! Killing jars were made by lining the bottom of a discarded mayonnaise jar with cotton balls that were treated with nail polish remover. For butterflies and moths unfortunate enough to be captured and kept, the end came quickly. After collection, the butterflies were mounted on spreading boards and left to dry flat with magazine strips pinned over their wings before being arranged in a case or frame.

Rich Feldmann was my partner in collecting, and we helped each other a great deal, often trading one species for another, or catching types of butterflies we knew the other wanted. The red-orange Monarch was the prize catch in the butterfly family, especially females that had the broader, black, vein markings on their wings. Next in line were the swallowtails, and the other species descended in importance down to the checkers, hairstreaks, skippers and whites. Moths were in a class by themselves where the green Luna Moth reigned supreme, followed closely by the Cecropia.

We literally had our field guides memorized and could readily tell anyone the type of butterfly spotted from one hundred yards away simply by their color, behavior and flight patterns. Our conversations must have sounded quite intelligent with words and names such as thorax, Great Spangled Fritillary, chrysalis and Polyphemus being tossed around as easily as other children spoke of bicycles, marbles and comic books.

Of course, we had a cornucopia of suitable collection locations from which to choose. There was the meadow that used to exist across from the top pond on Lloyd Road where one could see hairstreaks, checkers, swallowtails and fritillaries. The wooded areas were the preferred environment to find the Mourning Cloak, the first butterfly I ever caught! The field at the end of Gary's Lane was another treasure trove, providing a variety of habitats with the nearby stream, perfect for large Wood Nymphs, Little Wood Satyrs and the tiny, blue Spring Azures. Still another prized location was in the wild phlox grove below the old chicken coop. This area was especially good for hummingbird moths and skippers. If none of the above locations fit the bill, there were always our backyard gardens and flowering hedgerows, which were often filled with butterflies.

Netting these little critters demanded patience, quick reflexes and the ability to chase them down when on the wing. I can't begin to imagine how much energy was spent running all over God's creation after these colorful insects. Often we would take a swipe and end up with a net full of flowers or, worse yet, tear our nets on the thorny raspberry bushes. When we were successful in netting a specimen, it would be carefully handled, inspected and examined, and most often released. The thrill was definitely in the chase, and the combination of the warm sun on our backs, the sounds of the grasshoppers and breeze in the tall grasses and the scent of the wild fields rounded out our pleasure.

Vacations offered opportunities to collect different species. My family would go to Maine in the summer while the Feldmanns often went to Florida. I would come back with interesting tiger moths and White Admiral butterflies, and Rich would return with Zebra Swallowtails. Together we amassed quite a respectable collection, and the fascination still lingers. Even today I find myself watching for butterflies in gardens and remembering how it felt to have one fluttering in a net or to release one out of my hand. Every boyhood chase on which I was led by these insects was worth every step.

INDEPENDENCE DAY

There's something about summer and July fourth that always makes me think about my childhood. Perhaps it's the snapping of firecrackers or the warm, night air or the smell of burning sparklers. Whatever it is, I instantly think of my godparents' house, and one after another, the images come streaming through my memory.

There used to be a weeping willow tree in the Feldmanns' backyard, and this was the spot where the children's celebration always began. As

we anticipated the upcoming festivities, my friends and I would run under the tree, in and amongst the drooping branches. It was a fantastic place to play because the tree provided a secluded sanctuary underneath its domed canopy. We were in our own little, play-filled world.

About six o'clock in the evening the barbecue coals were lit, and the smell of fire-starter fluid and smoke drew us out of our play mode. Hot dogs and burgers would soon be on the grill, and no one wanted to be last in line. I loved the ritual of the barbecue: lighting the coals, letting them turn white and hot, cooking, toasting buns, making pitchers of ice-cold lemonade and roasting marshmallows. It was pure bliss, and I remember balancing my plate on my lap as I sat on the patio steps, listening to the grown-ups talk and watching the winking of the evening's first fireflies appear.

After dinner, firecrackers would take center stage. We were very closely monitored at this point of the night, but we didn't mind. The sheer exhilaration of the activity was something we anticipated for days. We would take turns laying single firecrackers on the stone steps and lighting them with matches. As soon as the powder on the fuse began to glimmer, we all ran back about twenty feet and waited with wide-eyed expressions until the firecracker exploded with a loud snap. One after another, each of about one hundred was lit, leaving the patio strewn with shreds of red, white and blue patterned paper.

Next on the list were sparklers, which glittered in the dark like fairies' and sorcerers' wands. We would stick them in the ground and light several at a time. Occasionally, we would hold them carefully at the end of the wire handle and draw our names in the night air. By this point, the smell of phosphorus and black powder hung thick in the air. It is a scent that I rather enjoy and can recall at a moment's notice.

However, the night was not yet over, for Mr. Feldmann had a secret weapon that he used as the finale of every Fourth of July celebration: a cannon. This was one of those small cannons that I remember to be about ten inches in length. It took a small charge and made an exceptionally loud bang. All the children and adults stood far away for this display, holding their ears. Again, I loved to watch the preparation. Mr. Feldmann would take the cannon out of its box, set it on the grass just so and load the charge. When he was satisfied with our positions, he would set off the thunderous explosion. Always, he would act as if that were the end, and always we would plead for one more shot. Like any good performer, Mr. Feldmann left us wanting more, but every year he also sated our desire with one last firing, the evening ending with the sound of cannon fire echoing into the Somersetin hillsides.

Tools of childhood.

YARD SPORTS

You just can't have a neighborhood full of children and not expect sports and games to play a major role in their recreation. Sports fields could be created almost anywhere with trees being used as bases, hedges as foul lines and hills as end zones. My front yard and Rich Feldmann's back yard, however, were the two most desirable locations for play.

On ground once used as kennel runs and the chauffeur's yard, terribly serious games of baseball and football were played by children pretending to be professional sports heroes. Gloves were oiled and conditioned with care, bats were taped for good grips and passing plays were diligently reviewed. These were not the days of sugary, fruit-flavored sports drinks. Our boundless source of refreshment came directly from the garden hose, and it remains the best tasting, coldest and most refreshing water I can remember. Of course, casualties occurred from time to time but nothing serious. Getting a bloody nose or the wind knocked out of you was the price you paid to be a major leaguer at nine years old. The worst thing that could be expected was a hardball, hit in just the right manner, to go crashing through a window. This happened to me a couple of times at the

121

Feldmanns' house, and when this occurred, I don't know which was more surprising: the fact that I broke a window or the realization that I actually hit the ball so far. It was shock, fear and jubilation all rolled up into one glorious moment.

You would be hard pressed to match these days of exhilaration as an adult. The admiration of your peers for a completed pass or a good hit was relished, especially after some creative maneuvering. Remember, we were not playing on a regulation field—far from it. Football huddles usually sounded more like trail descriptions than plays: "Go out about twenty feet and hook around the cherry tree, fake left toward the rock and then head straight up, and I'll pass it to you by the pine tree." When it worked, it was magic!

APPLE FIGHTS

One of Norman Hankinson's fondest memories of growing up on the Lloyd Estate involved throwing apples. He would launch them by impaling the fruit on the end of a sharpened stick and send them flying, lacrosse style, with plenty of distance but not much accuracy.

A few living apple trees remained around our house and neighborhood as reminders of the orchard that once existed there. Some were very old and gnarled such as the one in our back yard; others were younger and bore surprisingly large fruits. Tucked behind and on the Packards' side of a row of large forsythia bushes was a stand of several apple trees, one of which had a treehouse built in it.

On occasion, the boys in the neighborhood would collect these apples in the fall and challenge each other to apple fights. I must confess that I was always leery of this activity, as it seemed to be much too dangerous. Who wants to put themselves in a position where they might get whomped in the head by a hard green apple? Despite my unwillingness, I often was coaxed into playing, and we set about choosing teams and selecting areas that provided both a protective shield and a good shot at the opposition.

The skirmishes commenced with very few rules to follow. Basically it turned into a situation where it was "every man for himself," and the driving thrust was to "hit 'em in the middle with everything you've got!" The likes of such a battle, we thought, probably had not existed since Gettysburg, and the yard was at once a blur of flying green projectiles, the spattering of fruit and juice, exclamations of pain when an apple hit its mark, boys scurrying back and forth trying desperately to avoid being hit while gathering ammunition the other side had thrown and the occasional tactical assault that two or three of us would launch with only the shred of a plan.

Invariably, the game, or war, was eventually ended in an abrupt fashion when one of the boys—and it seemed very often to be me—suddenly began crying and running home after being struck in the head or eye by one of the "fruits of wisdom." The bad hits never left any permanent damage, and apologies were always accepted, but I wouldn't suggest this activity to anyone not willing to pay the painful price of a bruised and pummeled body.

HARVESTING

Caught in between those languid days of early autumn and the bracing days of winter is the harvest season. In the era of the Lloyd Estate, the land around my boyhood home looked over an apple orchard of significant size. Surely a good deal of time was spent trimming the trees, spraying the fruit, and when the time was right, harvesting the apple crop. Of course, my family had none of this type of work on our hands, but the apples produced by the handful of remaining trees did not go unused.

My mother was a harvester. She hated seeing fruit go to waste and found many ways to use it. The cherries from the tree in our front yard were collected and turned into pie and jelly. Wild raspberries and blackberries were turned into jam, and dandelions were even picked and turned into wine on one occasion. But it was the apples that attracted annual attention.

Year after year, my mother, whom I seem to always remember wearing a blue checked dress, would take empty wooden bushel baskets and fill them with the fruit. At times I would help by climbing up in the trees for the higher, ripe apples, surrounded by the heady scent of ripe fruit wafting in the air, while my mother would pick from the lower branches and select some of the better apples that had already fallen to the soft grass below the trees. A few of the ripe apples that were picked off of the trees were eaten outright, but the majority of them went into her pies and apple coffeecake.

My mother had a reputation in the area of being a talented baker. "A touch of the divine" was how one neighbor described the quality of items that emerged from our oven. The scent of her baking filled the house and drifted outside our home when her culinary magic was being wrought, and we all impatiently waited, mouths watering, eager for a taste. Her apple coffeecake was famous in the area and became an item in high demand in the neighborhood. One might call it one of the "tastes of Somersetin." It seems only fitting, therefore, to share this with you all, so you can immerse your senses even more in the area and its history. My mother notes on her recipe that this is the best recipe of all that she has tried. I hope you enjoy it

Rusted, antique harvester.

as much as I did, and if you are able to pick your own apples and leave the cake to cool on an open windowsill, it will be even more rewarding.

Even the less desirable apples had their uses, ones that lasted far beyond harvest time. You see, the fallen fruit would lay and rot, attracting yellow jackets and wasps. To prevent overly large numbers of these insects from accumulating around the bases of our trees, my mother would collect the apples she couldn't use for baking and store them in baskets in our garage. There they would dry, and when winter and its snows arrived, my mother would toss them out to the waiting deer that liked to eat our yew shrubs outside the dining room window. She would also throw some of the fruit into the front yard where the deer would come to feed as well. The deer got to be quite used to us, for they knew we wouldn't harm them. Even the throwing action when we tossed the apples didn't seem to cause them alarm.

When spring arrived, my mother would use up our stockpile of dried apples on the deer, mixed with damaged and spotted apples that she got for pennies per pound at the food store in town. The deer would sleep in the tall grass on top of the slope in our front yard, so they didn't have to go far to feed. Every year there was a doe that gave birth to her baby, and sometimes twins, behind the Swamp Willow tree. In time, the mother deer would lead her fawns out to introduce them to the surrounding world, and

they would all eat the apples my mother left for them on the hillside. It was an amazing sight, and I delighted in the complexity of it all, thinking how our trees' fruit of the previous season were being enjoyed by new life, and how my mother was assisting the mother deer—a mysterious, maternal connection communicated in the peace and trust within the eyes of my mother and the doe.

Mildred Ward's Somersetin Apple Coffeecake

8" square or round pan
Preheat oven to 375°

1 cup all-purpose flour
½ cup sugar
1 teaspoon baking powder
½ teaspoon salt
½ cup firm butter
1 egg
¼ cup milk
1 teaspoon vanilla
2 or 3 medium-sized apples peeled, cored and sliced into 12ths
3 tablespoons sugar
1 teaspoon ground cinnamon
½ cup chopped walnuts (optional)
butter

In medium bowl, put flour, sugar, baking powder and salt. Stir to mix well. Add firm butter, cut into pieces, and with pastry blender, or two knives, blend until butter is the size of peas. Thoroughly mix egg, milk and vanilla in a small bowl. Add this to the dry ingredients, stirring until well incorporated. Spread into greased and floured pan (or spray with PAM® and flour, if using non-stick pan). Spread dough up the sides slightly. Place sliced apples (cut into 12ths) on top of dough at a slight angle and close together—circular for round pan and three straight rows for square pan. Mix sugar, cinnamon and nuts, and sprinkle mixture on top of the sliced apples. Dot with butter. Bake in preheated oven for 40 minutes. Serve cold or warm. This recipe may be doubled and baked in a 9"- x 13"-pan.

Try topping with vanilla ice cream. Instead of apples, substitute or mix with sliced plums or peaches.

Halloween

Halloween is a particularly memorable time for me as I think back on the preparations that went into this holiday as a child. When I was very young, my mother and I would hang and tape cardboard decorations all over our outside porch and interior entrance hall. Skeletons, witches, black cats and jack-o'-lanterns loomed from every corner, and ghosts made from sheets hung next to the front door. After this was finished, I would start to draw faces for the jack-o'-lanterns. My father would always carve the pumpkins late in the afternoon, and I would delight in the smell of a freshly cut pumpkin that would reveal its wealth of seeds. When the carving was done, my father and I would set our creations out on the porch and place the candles inside the jack-o'-lanterns, and my mother would bake the seeds in the oven.

While waiting for the seeds to finish, my father would haul out his Webcor reel-to-reel tape recorder, and I would begin recording a spooky soundtrack for the trick-or-treaters. In hindsight, the soundtrack must have been very funny because it consisted of frightfully dramatic lines such as, "Beware of the ghosts!" and "If you step on the porch, you will die!" After I had recorded a good ten minutes of screams, gurgles and warnings, the tape recorder would be propped in one of the porch windows to allow the soundtrack to be heard outside.

Then came the trial run. Later, when it was dark and the seeds were baked and salted to perfection, I would turn off the lights in the house, light the jack-o'-lanterns, switch on the tape recorder and observe the fantastic sight of flickering demonic faces on our porch, complete with sound effects, while munching pumpkin seeds on our lawn.

Costumes took a great deal of thought and preparation. They were never store bought, and I was definitely of the opinion that Halloween costumes should be frightening. No clowns or cowboys for me! It had to be scary; that was the bottom line. My costumes ranged from ghosts to scarecrows and monsters, but the best of all was the headless horseman—minus the horse. My mother spent days making this costume, and it was ingeniously conceived. The basic structure consisted of a cardboard box that was cut just so to fit over my shoulders. Holes were made in the sides for my arms, and a small opening was cut into the front, so I could see. The box was draped with black cloth to look like clothing and a cape. Black pants and shoes completed the costume. A fake, white collar that was positioned on top of the box completed the illusion along with the plastic jack-o'-lantern that I carried under my arm, which served a dual purpose as my severed head and candy container. Walking from house to house proved to be difficult, as

I had limited peripheral vision through my sight hole in the box, but I had a great time. To be sure, no one else had the same costume that year.

Later on, when I was feeling a bit too old to trick-or-treat, yet too young to give up on the idea of free candy, Rich and I hatched a plan to maximize the potential of the holiday. We decided to trick-or-treat as undertakers. It seemed like a wonderful idea. The costumes were easy—simple black suits fit the bill—but we needed something more, something to identify our morbid trade, something like a coffin. A coffin! That was it! We needed to build a coffin to carry between us, and we set about procuring the wood, nails, handles and paint from our homes and our parents.

The plans were drawn up, and the assembly took place in Rich's garage. Built in an elongated, hexagonal style out of sturdy, three-quarter-inch plywood, the finished product was painted black and came complete with brass handles, courtesy of Rich's father. We were proud of our creation and couldn't wait for Halloween night. Did I mention it was large enough for Rich or me to fit inside? This was an important feature because the space was not designed for a body; it was created for far more precious cargo: candy, and lots of it!

We planned our route down and up Lloyd Road, up Winding Way, along Stone Fence Road and across to Tower Mountain Road, a round trip of about two and a half miles. This was most likely going to be our last year of trick-or-treating, and we were going to milk it for everything it was worth. Finally the time came to don our suits and head out into the night. Armed with flashlights, coats and pillowcases for our treats, we stuffed them into the coffin and headed down Rich's driveway.

Now, the box we carried was no lightweight. In fact, it was downright heavy for any one of us, but together it was manageable. We negotiated all of our neighborhood and Winding Way without a hitch, but Stone Fence Road brought increased weight from all the accumulating candy, and we found ourselves pausing in between houses to switch arms and sides. You see, candy in moderation is great, but by the time we hit Tower Mountain Road, we began to see the flaw in our greedy plan. Our muscles were fatiguing, and we had so much candy that it was becoming very burdensome to lift and carry this three-quarter scale, wooden coffin filled with sweets, coats and flashlights. I felt a little like the greedy sultan in a story I had read who drowned in his own gold.

There we were, about a mile from our houses and dreading the inevitable chore of getting our spoils home. Up and down the hills we climbed, dragging our box through neighbors' yards, down driveways and over curbs. Somewhere along the line, one of the hinges on the box pulled loose, and we had to deal with a flopping coffin lid. We were quite a sight, and I remember

becoming envious of the little children as they scampered lightly away from doorways, delighting in their small bag of treats.

However, we were not to be defeated, and finally the light of the Feldmanns' house came into view. We had learned an important lesson that night, a lesson about greed and wanting more than one needs. We had paid the price for our miscalculation through our sweat and aching arms and shoulders. Stepping through Rich's front door, our ordeal had changed our outlook on what was important in life. Well, okay, maybe only for a second or two. All it took was one look inside our coffin to make our minds run wild. There was what seemed to be a mountain of candy of every kind. Spilling out our sweat-earned spoils upon the living room floor to count and divvy it up, we considered what we had learned that night, just long enough to decide we should do it again—next year!

Birdfeeders

My father was fascinated by birds. He watched them, sketched them, carved them out of basswood, counted them during migrations and even rescued a few injured ones from time to time. It was, however, the feeding of the birds around our house that has left one of the greatest impressions upon me.

There was a window feeder, which my father made, that was mounted outside our dining room window and faced the driveway. As wide as the window and about seven inches high and perhaps one foot deep, it had a top made of glass. It also had an adjustable flap that protected the inside of the feeder from wind, rain and snow. Smaller birds, such as chickadees and finches, were able to enter the lower portion, and jays, cardinals and other larger birds ate off of the glass top. All of this provided a means of observing a variety of birds at the feeder while protecting the seed and the feeding birds.

We had a large tin can with a tight-fitting lid in which we stored the seed that sat on a shelf beside our basement steps. Every few days during the winter, my father would carry the can into the dining room to refill the feeder. To this day I can remember the metallic, clanging sound that the lid made when it was removed. Inside was a custom mixture of sunflower seeds, millet and peanuts that my father mixed by hand.

Refilling the feeder was accomplished quickly by opening the bottom sash of the window. Cold air spilled into the room, and the wind often blew snow and some of the old seed and husks onto the floor. The scoop was a long, hollowed out gourd, which proved to be quite functional in scooping the seed and delivering the contents to the feeder through both the window and the opening in the back of the feeder.

After the filling was done, we waited for the birds to appear. We had many different species at our window, and I could name them all at a tender age. I still have the Audubon guidebook that belonged to my father, the same 1951 copy of *All the Birds of Eastern and Central North America* that I pored over as a child, remembering the smallest details of the colored plates. Carolina Wrens were as well known to me as the Black-capped Chickadees, and I could tell the difference between many species just by their calls, silhouettes and flight patterns. Indeed, I remember venturing out early on warm spring mornings to record the birdsong amidst the silent backdrop of Somersetin, and then settling down on the wooden step of my front porch to identify their calls. It seems my father's fascination had rubbed off on me, and it has stayed with me to this day.

Gray Squirrels are usually considered pests at birdfeeders, managing to find their way onto almost any feeding station and eating most of the seed placed out for the birds. Indeed, it became an enjoyable pastime to keep watch and foil their attempts by scaring the squirrels, rapping on the window at the very moment they jumped up on our feeder. However, my grandmother had an alternative plan and developed a knack for feeding the squirrels on our window feeder, a strategy that succeeded in satiating the squirrels' hunger while sparing more seed for the birds. After spreading peanut butter on slices of bread, she would open the window, tap the bread on the feeder's glass top and leave it there for the squirrels to find. The squirrels became conditioned to this sound and eventually came running, sometimes five or six at a time, to get the bread. After carrying off the full slice of peanut butter bread in its mouth, each squirrel would find a comfortable place under our yew shrubs, or on top of one of the fence posts or rails along our retaining wall, and nibble away at its treat. It didn't take long until many of the squirrels, wild as they may have been, actually mustered the courage to jump up on the feeder and take the bread out of our hands. Well, you can imagine how exciting that was to a young boy, and I remember that my grandmother found it rewarding and looked forward to this activity as well.

The most awaited event was the migration of the Evening Grosbeaks. These brightly colored yellow, black and white birds would congregate at our feeder in groups of up to twenty at a time. Their chattering was thrilling to hear, as many more of them perched in our yew shrubs or the Double Oak tree, awaiting their opportunity to feed. The grosbeaks stayed only a few days, and then they would be gone as quickly as they had appeared.

On several occasions we were treated to the rare sight of a Pileated Woodpecker on our old apple tree or suet feeder. Of course, it was much more exciting to see this magnificent bird on our suet feeder because it was

closer to the house than the old apple tree that sat at the far edge of our eastern yard. Fashioned out of wire mesh that was wrapped around a board, the suet feeder was nailed to one of our fence posts along the retaining wall just outside our dining room window. Pileated Woodpeckers, with their distinctive, bright red crests, are about the size of crows and loved to eat the suet, and whenever one of these was spotted, everyone ran to the window to look. One would think John James Audubon himself was standing in our yard with all the fuss we made about one bird, but it instilled in me an appreciation for wildlife. I was taught the importance of preserving habitats, how the actions of man can have a severe impact on animals and how conservation begins with me, and everyone else, as an individual. My father was no standard bearer for nature. Rather, he taught through his actions and his teachings. I began to see nature as a precious gift, one that demanded and deserved respect, appreciation and continual care.

A Winter's Walk with God

I don't remember hearing God speak to me that night, but I understood His message. Neither do I recall God's image, but I knew His presence. We met on a winter's walk of approximately 200 yards between the home of my friend Rich and my own.

The year was 1969, and, as a ten-year-old, the journey home after playing with friends or being dropped off by the school bus was one that I knew well, and followed a predictable route but allowed for decompression. Most of the time I would travel either through the Feldmanns' back yard or along the Packards' crushed-stone driveway to a small, white garage. From there I would cut across the Packards' hillside property to a break in a row of thick forsythia bushes. This opening allowed me to gain access to the southern corner of our property and walk across our side and front yards to my front door. The route cultivated a certain sense of independence and separation from the rest of the world, and in warmer months, surrounded the traveler with grass, trees and dense and often flowering shrubs.

On hot summer days one had to be careful not to be stung by yellow jackets, which often nested in the grass. I learned this lesson the hard way by ignorantly walking through myriad of these painful little creations after they were distinctly perturbed by our neighbor's lawn mower that had just passed over their nest. Swatting at my pant leg, which many of them had managed to enter, I ran jumping and yelling like a boy possessed all the way home, breaking speed records that I was later, much to my chagrin and to that of my coach, never able to replicate on the track.

In contrast, winter travels left their own unique impression. At times the snow was crusted enough to allow a boy of my former size to walk on the top of the ice-capped snow without breaking through to the ground a foot or so beneath the surface. This slippery crossing, along with the occasional, unexpected breakthrough, added adventure and challenge to the trek. One journey in particular impressed me with one of the most poignant and peaceful epiphanies of my life.

Midwinter nights at Somersetin can be extremely crisp and frosty. On one such night I found myself bundled up against the cold and walking home alone after an evening of night sledding and hot chocolate, eager to reach the heated hallway that awaited me on the other side of my front door. It was silent except for a frigid breeze that whistled across my face, and the crystalline snow that squeaked and crunched underfoot. The sky, black and cloudless, served as a backdrop for a heavenly stellar performance. Twinkling stars seemed scattered as so much glitter on a sable velvet cloth, and a half moon, high in the sky, looked back at me and kept me company.

Just after rounding the corner of the Packards' garage and without warning, I felt a sudden compulsion to stop and raise my eyes upward. What once was a feeling of fortified resistance against the cold was replaced by an overwhelming flood of warmth that completely enveloped me. This was accompanied by a deeply comforting sense of peace and the firm knowledge that I was not alone at that moment, nor would I ever be. I was taken by surprise and overwhelmed, transfixed and staring up into the face of heaven. The incident itself lasted for perhaps thirty seconds, but it impresses and affects me to this day.

I don't remember the second half of the walk that night, nor do I recall arriving home. But I do remember, later that evening, looking out through my frosted window at the night sky from underneath my cocoon of blankets, knowing that we are all loved and closer than we think to our Creator. I had been taught something very precious. I had come to understand that when we unexpectedly break through the crust of life's journey, God is there to lift us up, and when we desire warmth on the long, dark walks of our lives, our Creator blankets us and enfolds us in radiance.

Although I do not speak of it often, that evening, years ago, has remained etched in my memory as the first time I felt a personal connection with something eternal—a connection with God. The boy, who seconds before had been immersed in thoughts of speedy Flexible Flyer sleds and mugs of hot chocolate, had undergone a profound change. Awareness is a spectacular gift of grace for us all. I know I was not expecting or looking for anything or anyone that frosty night, but something beloved had found me.

Events and Pastimes

When you are old and grey and full of sleep,
And nodding by the fire, take down this book,
And slowly read, and dream of the soft look
Your eyes had once, and of their shadows deep...

—William Butler Yeats, "When You Are Old"

Tractor Rides

Jack Hankinson has told me of an entertaining event in which he was involved when he was very small. Apparently, one of the older girls who lived on the estate delighted in taking him for rides around the grounds in a pony cart. Forty years later, I would come to relish a similar childhood memory.

We had a two-wheeled wagon that my father used to hook up behind his two-wheeled Gravely tractor. More of a work cart than a wagon, this form of transportation was just as enjoyable. Bouncing up and down and holding tight to the sides, I enjoyed these rides immensely as my father towed my grandfather Eugene and me across and around our yards. Sadly, my grandfather passed away while I was very young, but not before creating some extraordinary memories.

Navigating the slopes and hills and the various roots, gullies and rocks added to the excitement of the ride as the Gravely's engine spluttered and stuttered and emitted intermittent puffs of white exhaust. These rides usually took place in the early evening, just after dinner, and were punctuated with the cool, somewhat damp air of twilight and the flickers from fireflies as they slowly rose from the grass that slid along and underneath us. Our acre

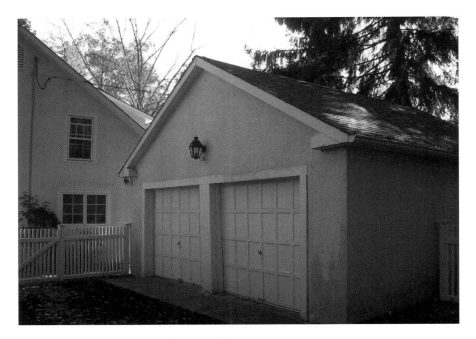

Garage doors and a side view of the author's former home.

and a third seemed much larger on these rides, and the gathering darkness created a fertile environment for a little boy's imagination.

Grass Hideaways and Summer Storms

My father had a tendency to let the grass grow to tremendous heights before determining that it needed to be mowed. As we lived in a secluded area, there were no neighbors close enough to mind, and the knee- to shoulder-length grass was a treasure trove to children.

Gone to seed and bearing long, soft stalks of wild grasses, it was easy to make paths through the yards. It was like a mini transportation system with certain routes leading to my house, others toward neighbors' homes, and still others leading to no place in particular. Some led to hidden rooms that were created in the far corners of the yards. These rooms were made much the way deer bed down, and it was a simple procedure of walking around in larger and larger circles until you achieved the desired size. You might say they were the forerunners of crop circles!

My friends and I would make our own rooms and create a neighborhood of sorts. We would visit each other's hideaway by means of the paths linking

Grass gone to seed and afternoon clouds.

them together, and time would be spent talking about almost anything, telling jokes, or revealing which girls we secretly liked in school. Most of the time, it was with a stem of long grass that had gone to seed between our teeth because it was the "cool" thing to do. The grass was even used for communication. While reclining in a newly created space, grass whistles were easily made by reaching back, picking a blade of grass, and holding it in between the first two joints of your thumbs, blowing through the opening in such a way that it made a loud, screeching sound. This was a popular signal call, and it seemed, once, to be just as natural to hear as any of the other sounds in the country. What's more, lying down meant that you seemed to disappear into the grass, which made it excellent for games of hide-and-seek. It was there in the grass that confidences were established and secrets were often shared, echoing only in the sound of the wind-blown, whispering rye.

Of course, as much as these grass rooms were cherished for their peaceful settings, I could also lie back and watch the clouds build in a late summer sky. Cumulus clouds would sometimes give way to cumulonimbus that expanded upwards to enormous heights, reminding me very much of towering heaps of billowy whipped cream. Before long, the summer skies would darken, and the late afternoon would be transformed around me. Blue skies and white clouds gave way to deepening shades of gray. The

gentle breeze matured into a swell of hurried wind, making the grass hiss, and a few dislodged leaves might suddenly take flight to sail on the brisk current. Small birds would begin to fly in an agitated state between trees while crows, fighting to hold their course in flight from lone treetops, would seek shelter in thicker stands of trees.

In the midst of all of this, I would lie there in my nest of hissing grass long enough to watch the thunderstorm build and roll in from the west. Soft rumblings began to be heard far in the distance. As they grew louder, I began to watch for lightning flashes and count the seconds between the flash and the thunder. Every five seconds was equal to another mile between me and the lightning, and I could calculate the distance between each bolt of lightning and me, hoping not to let any get too close, but I was waiting for something—my favorite moment. As the storm approached, leaves became birds, birds became clouds and all was scolded by frenzied branches that waved and bent in submission to the impending storm and crackled like the sails and tails of buffeted kites. Thunder merged with blowing wind and tousled grass, and all within the scope of the senses was blended and intermingled in an ever louder and deepening gloom—and then it happened.

It is the silence I cherish and remember most. It is that sudden hush, that spell of stillness that seemed to have substance but loomed just out of sight and reach. The presence could be sensed—a giant who suddenly drew in and held an enormous breath and with it all the sound and air that had, just a moment before, been swirling around my head. I love the surreal quality of these moments, waiting for the expected and inevitable release.

As quickly as it had arrived, the silence would be broken by a wall of wind, a downdraft from the thundercloud, blown out ahead of the storm, and it carried that distinctive odor of ozone created by the high voltage in the storm. On the heels of this tempestuous calling card was a flash of lightning, a sharp peal of thunder and then the rain would arrive. The initial raindrops were very large, sparse and scattered and would make audible splats upon my head and the exposed skin on my arms. However, this would only last a few seconds before a steady and drenching rain would begin to fall in earnest, and I would abandon my grass hideaway, surrender the field and retreat to the safety and cover of my home under the soaking, summer deluge and angry, clamorous sky.

Grass and Driveway Railroad

When it was time to mow the grass, I always looked forward to playing railroad in paths that my father would make for me. For a long period in

my childhood, I was fascinated by trains. I had a blue and white striped engineer's suit complete with a cap and an HO scale model train set with steam locomotives, cabooses and an array of flat cars, box cars and gondolas. Being able to use my imagination outside was irresistible and something my father supported.

Unfortunately for my father, the act of cutting the grass meant getting our Gravely tractor, a beast of a machine, started. It did not have the luxury of an electric starter, so my father would have to do it by hand. It was a routine I knew well, and as soon as my father pulled the mechanical monster out of the garage in the late afternoon, I ran to the living room window and pressed my nose to the screen to watch the battle between man and machine. After filling the gas tank between the handles, my father would adjust the control levers and wrap a leather strap around the starting wheel at the lower rear side. This being done, he would position himself to get as much leverage as possible and pull with all of his might.

No one spoke to my father when he was attempting to start this lawn mower, but he had a running dialogue with the machine that incorporated a predictable pattern of swearing and cursing that started as a low grumble and built to a crescendo of sharp, bold expletives. Time after time, he would wrap and pull the strap. Time after time, the Gravely would either just sit there or sputter out a few puffs of gray smoke, only to give up the ghost. This pattern continued for ten to fifteen minutes or more before, finally, the engine would spring to life with a roar that was sufficiently loud enough to drown out the final words of damnation that my father had for the machine. Then it was time to cut.

To me, the paths created in the grass were imagined railroad tracks, and I delighted in wearing my uniform and following my father as he walked behind his Gravely tractor, the smells of gasoline, freshly cut grass and hot exhaust combining in the twilight. Knowing my love for trains, he often made loops and paths in the yards the day before he cut the entire expanse. This left a day for me to play engineer. Occasionally, the skids on the tractor's blade housing were used to make double-lined tracks at the top of our gravel driveway. This was a special treat because I found that I could go back and make lines across these "rails" to look very much like railroad ties. Round and round I would go, pumping my arms like pistons and making whistle sounds. Yes, I must have been quite a sight!

CLIMBING TREES

What child does not like to climb? High up on a limb—well, maybe ten feet—you were master of your domain, a pirate high up in a crow's nest,

Tarzan of the jungle, or a circus acrobat. Indeed, in his day, Norman Hankinson delighted in climbing the cherry tree behind the garage along with an ash tree that once stood in front of the Top Kennel, and I was carrying on the tradition.

The number of good climbing trees around me could not be counted. There were spruce, dogwood, ironwood, willow and even the tall Ailanthus trees, also called the "Trees of Heaven," that grew tall with very few lower branches and could be shimmied up without much trouble. There was one particular grove of Ailanthus trees that grew behind our garage and offered choices in trunk diameter, each one as straight as an arrow. Perhaps the simile would be more accurate if I said straight as a pirate's ship mast or a fireman's pole or a Tarzan jungle vine, for these items better complemented the characters I would imagine myself to be. The idea was to gain as much height as possible and rock in order to make the tree sway from side to side. While I had nothing on Robert Frost and his birch swinging, it was an exciting way to spend my time. I must admit that I was always a better climber than shimmier, but that never stopped me from trying to make my way up the tree.

Some climbing trees became personal favorites and were given creative names, such as Rich's Tree or Gordon's Tree—you get the idea—but these were the trees we became as one with. Climbing and moving effortlessly through the branches like a monkey in the rain forest, we knew just where to step, just how to grasp the branches and how to get in and out of the tree with ease. Without a doubt, the importance of a good climbing tree in the life of a child with imagination must never be underestimated.

Forsythia Tunnel

The forsythia hedge that ran between the Packards' property and ours was much more than a boundary marker and colorful shrubbery; it was a secret spot that provided a direct link between our property and the Feldmanns. Indeed, it was at a break in this hedge where I first met my friend Rich when we were four or five years old. Our mothers had arranged for the meeting and sent us both out to rendezvous at this midway point between our two homes. Both dressed as cowboys, complete with hats, holsters and guns, we surprised each other coming through the hedge. After a brief, western-style standoff over whose corner of God's country was to be the play site, this close encounter resulted in both of us simultaneously heading for the hills and bolting for home. I guess our little slice of the Ponderosa wasn't big enough for both of us. Neither of us was expecting to see another "gun"

in town, so I guess we thought it best to retreat, for the time being, to our respective sides of the forsythia hedge, as it was a thick, substantial barrier.

However, underneath all those tangled stalks and branches of forsythia lay a network of tunnels that could be explored for fun, used as an obstacle course, or picked as a secret meeting spot. Inaccessible to adults, a child could crawl and wriggle through the maze of passages over a distance of one hundred feet or so. True, you would get dirty, but we certainly didn't care, and the challenge fueled our imaginations. Some favorite games of ours were to pretend we were soldiers trapped behind enemy lines and fighting our way through barbed wire, or spies on a mission to deliver sensitive information to our leaders. In addition, the dense growth and foliage above our heads served as cover in the rain, several times allowing us to wait out a brief shower before emerging to play again.

Bike Riding

The dirt and gravel right-of-way that ran in front of the Feldmanns' house and up to the Rankins, served as a location for great amusement. Whether catching butterflies on the goldenrod that grew along its edge, or testing one's throwing arm by launching stones over the embankment and into the pond, the right-of-way was a playground for us.

One of the favorite activities was riding our bicycles up and down this grand thoroughfare. With its slight incline on the upper end, the crown of loose gravel in the middle and ever-changing potholes, we were presented with somewhat of an obstacle course. At the time, no one thought about wearing helmets— something that, in hindsight, I wished I had had on a couple of occasions. Falls occurred every once in a while, and I bear a scar on my stomach that serves as a physical reminder of one of them. But the rides were thrilling.

I had a red Schwinn cruiser, and Rich had a cruiser-style bike as well. Complete with mirrors and bells, both of our single-speed bikes also had those wide balloon tires that are great for gravel roads. They were also good for skidding, and we used to have contests to see how long we could make our skid marks in the dirt road. Beginning at the top of the drive, we peddled down around the curve, riding that fine line of being in and out of control, built up more speed on the flat and then hit the brakes in front of Rich's house. Our coaster brakes created a cloud of dust that we felt looked very impressive, and if you had a playing card clothespinned to one of your rear wheel's spokes to sound like a motorbike, well, you were untouchable, you were Easy Rider and you were king! As we got older, we ventured out onto other roads, but nothing seemed to equal the shared experiences we had on the right-of-way.

Radio Flyer Wagon Rides

One vivid memory I have of my paternal grandmother, Charlotte, who lived with my family, involves a little red wagon. It was a great enjoyment of my grandmother's to go for walks along the country roads. Having lived for the majority of her life in New York City, the country must have been a big adjustment for her.

When I was three years old or so, my grandmother would put me in my Radio Flyer wagon and take me on a lengthy, circuitous journey. She would pull me down the hill on Gordon's Lane from our house and turn left onto the old wagon road, which would come to be known as Gary's Lane. Traveling along the wooded road, we would continue out to Washington Corner Road and turn left. After nothing but gravel and dirt surfaces up to this point, the blacktop of this road must have been a relief for this sixty-one-year-old woman! On we went to Mendham Road where she continued left and up the small hill on Mendham Road before reaching Lloyd Road and the downhill slope to Gordon's Lane, which led us back home.

A small feat this was not, and try as I may, time has erased any approximation of how long this journey must have taken. What has remained, however, are the ever-changing views and the fun I had bumping along in tow.

Midnight Fire

One night I was awakened by my parents who were quite alarmed. I was taken down to the kitchen window to see a vision that, in hindsight, posed no threat to me but frightened me a great deal. There before me was my neighbors' ranch house up in flames. Tongues of fire leapt from the roof and windows, and although it was dark, the headlights from the fire trucks illuminated the vast amounts of smoke and steam that billowed up into the night air. Flashing orange and red lights shone through our windows and raced across our kitchen walls as we stood and watched in the dark. I felt fear for the dog and the people who lived inside, and I was worried that the fire might somehow travel up the hill and ignite our home as well. However, after my parents assured me that our home was not in danger, I felt a little better.

The next morning allowed us to see the charring and the damage that was done the night before. Thankfully, we learned that no one was hurt in the blaze, and our neighbors would be able to repair the damage. Being about four years old at the time, I remember this as the first occasion that I became

aware of tragedy and hardship being able to invade my world. The smoke, which we witnessed the preceding night, carried with it our neighbors' personal dreams and sense of security, and a part of my innocence as well.

Fire at Stonemere

I remember the sirens, lots of them, racing up from Bernardsville and along the stretch of Mendham Road that bordered the Rankins' field. There were not as many roads or houses in 1969, so it was easier to track the probable destination of emergency vehicles. The sound carried well, and I knew by the amount of commotion that something big was happening.

Where were they going? Was it a house fire or a traffic accident? Did it involve our neighbors? I stood on our porch and waited for my next clue. The wails of the sirens and the groans of the trucks began to surround me and come from many directions. Many still could be heard approaching from the direction of town and climbing Mendham Road, and others sounded as if they had turned and stretched out along Washington Corner Road. At the age of ten, I knew that Washington Corner Road was the last side road in Bernardsville under our fire company's jurisdiction. Anything much beyond it drew a response from Mendham. I also knew that a fire on Hardscrabble Road would have sent the trucks down Lloyd Road as a more direct route. Whatever this was, it was on Washington Corner Road, and it was very close by.

Running up our neighbor's driveway afforded me a good lookout over the small valley between myself and the sounds of the trucks and offered a direct view toward the crest of Washington Corner Road. The spectacular sight that captured my attention was awesome and startling. Stonemere, once the former Hulshizer mansion, which had been converted to a nursing home and still commanded attention at the top of the hill, was ablaze, and great billows of smoke poured from its roofs and windows.

I would not classify myself as a fire chaser, but this was huge news in our little corner of the world, especially for a ten-year-old, so I wasted no time in setting out for the scene. Dashing inside our house, I announced the news to my mother and grandmother, grabbed my bike and headed down our driveway. Peddling down the hill and along Gary's Lane out to Washington Corner Road was easy and seemed to take only seconds, but my pace was slowed upon reaching the hill that climbed up to Stonemere. My red Schwinn coaster bike, for all the abuse it could take, was not a hill climber with its single gear, and I was a bit on the husky side as a child. It wasn't long before I was pushing my bike up the road while being forced to consider

the magnitude of the situation. Fire trucks, police cars, the personal vehicles of volunteer firemen and ambulances caused considerable traffic, and I stepped off the road several times to let some of them pass.

Upon reaching the crest of the hill, I remounted my bike and rode down through the lower gates, up the driveway, and across the field that lay beneath Stonemere. I saw more activity than my eyes could comprehend at once. The scene in front of me was a myriad of flashing lights and people scurrying about. The sound of loudspeakers cut through the smoke, and thick, black hoses lined the street. Water was being sprayed in high arcs from the ground and from ladders in an attempt to slake the thirst of the flames within the stone and wood structure, and several individuals were dousing the small fires that had ignited in the surrounding grass. Here and there were little clusters of people standing and watching, probably as stunned as I was.

I don't recall how long I stayed to watch, but I do remember heading home with the uneasy thoughts of how the elderly inhabitants inside Stonemere had fared. The next issue of the *Bernardsville News* carried a big story on this event. The cause of the fire was unknown, and according to the caretaker, it broke out on the roof of the building. Apparently everyone escaped or was removed unharmed, but the proud, dominating Stonemere was a shambles. There was no reclaiming it, and it wasn't long before the burned shell was demolished and cleared away. In its place today stands a large, single family home; one which possesses an equally commanding view of the surrounding hills in a location once charred by smoke and flame.

While we're on the subject, there is an additional, interesting tale about Stonemere, which concerns a human skeleton that was discovered in between the third story floorboards and a false bedroom ceiling of the building. How did it get there, you ask? Well, Stonemere was built as a private residence in 1902, but it became a home for elderly members of the Order of the Eastern Star during the 1920s and the 1930s. It went on to become a private residence again in 1946 before it ultimately began operating as a private nursing home from 1955–1969. It was in 1937 that seventy-six-year-old Annie Christopher, an "inmate" of the Eastern Star Home, disappeared. This particular woman had an "erratic mental condition," had tried to leave the Eastern Star Home once before, and had a record of escaping from another home in New York as well. This time, however, she apparently crawled through a small attic door and got wedged between the rafters where it is assumed she died of exposure, starvation, or a heart attack. This area of the home saw little activity and stored disinfectants and medicines, so any cries issued by Annie Christopher went unheard, and officials presumed that the odor of her decomposition was masked by the

nature of the storage items. Her disappearance remained a mystery until her skeleton was accidentally discovered in 1947 when the building was the residence of Dr. and Mrs. John D. Currence. The remains were identified by an inscription on a wedding ring adorning the skeleton and a personal check in Annie Christopher's name found in a nearby purse.

FISHING PERMISSION

One warm day, Rich and I decided to try our fishing luck at the Rankins' Pond, which sat just above his house. Gathering our poles and tackle boxes, we started up his right-of-way to a path on the left that led through an opening in the barbed wire fence and up to the water. On this specific occasion, we must have been feeling particularly angelic because we hesitated at the fence and decided to ask permission from Mrs. Rankin before heading up to the pond. I use the phrase "particularly angelic" since there were several occasions when we would sneak up to the pond for exploratory expeditions without asking—somehow the risk of being caught made the adventure more exciting.

Nevertheless, we continued up the driveway to the large brick house at the top of the hill, mounted the stairs and knocked upon the screen door. We knocked several times before hearing a feeble voice responding with a faint acknowledgement and asking us to come to the kitchen. The main door was open, but rather than go through the house, we decided to go around the outside of the house to the back door. Knocking again, we heard the muffled voice again, this time through the rear screen door, telling us to come inside.

I should mention at this point that the Rankin house always impressed me as being a bit, well, mysterious, and it reminded me of a Charles Addams cartoon. Since Mr. Rankin's death several years earlier, Mrs. Rankin cared for the house as best she could with the occasional help of one of her sons, who we periodically saw driving up to the home. The house, with its diamond-paned leaded windows, presented a somewhat gothic facade, and it seemed gloomy. Adding to this was the fact that we rarely went up to the home, aside from riding our bikes down the right-of-way and trick-or-treating on Halloween. Furthermore, while I can't say that I remember being told this, there seemed to be an understanding that the house was off limits to our childhood excursions. Taking all of this into account, one would be correct to imagine that it was with some trepidation that Rich and I entered the house, dropping our gear and all thoughts of fishing at the door. As we crossed the threshold, I looked at Rich, and couldn't help

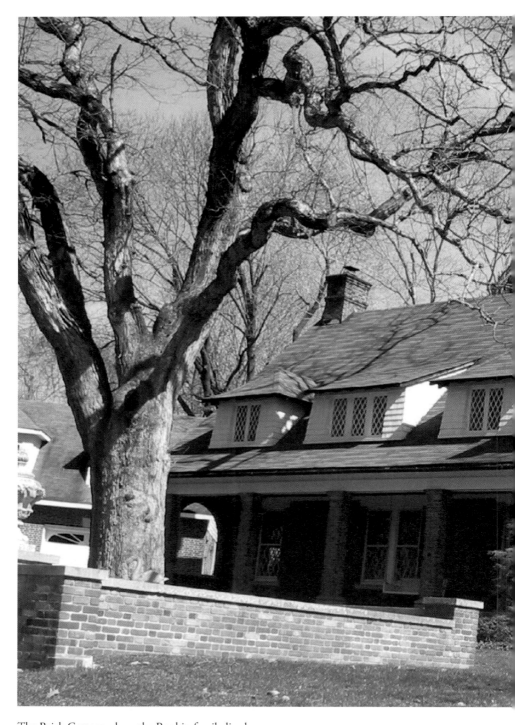

The Brick Cottage where the Rankin family lived.

thinking that this would have made a great scene for a film. You know—the part when the disembodied voice, beckoning the young innocents inside, lures them to meet their fate, never to be seen again. But what could we do? Before we knew it, we were inside the house at the top of the hill, the home that seemed to be out of bounds; the looming, shadowy residence that had remained a mystery to neighborhood children for so long.

Taking stock of the unfamiliar environment, we gazed into the kitchen and dining areas. Old, discarded newspapers, magazines and bags of bottles and cans were arranged in piles, so that paths were created to get from one room to another. The air had that musty odor that a house has after being closed up for some time, and we proceeded cautiously. Following the sound of the voice into the kitchen, we found Mrs. Rankin slumped in a chair with a fan blowing on her and just on the other side of a half wall that separated the kitchen from the dining room. She was very pale and confused, but she mumbled for us to call a doctor. At our young age you can imagine how alarmed we were!

I telephoned my mother who was a nurse, and Rich and I, not even recalling being able to feel the ground beneath our feet, raced down the driveway to get his mother as well. Someone called for an ambulance, but I no longer remember who it was. My mother arrived before the paramedics and tried to comfort Mrs. Rankin as best she could. We could hear the sirens grow louder as the emergency vehicles approached from town, and when the emergency squad arrived, we watched them place Mrs. Rankin on a stretcher and slide her into the back of the waiting ambulance, which whisked her off, lights flashing, to the hospital in Morristown. I think everyone was pretty shaken up, and some long hours were spent waiting for word on Mrs. Rankin's condition. It was just before dinner that Mrs. Feldmann received the call from the hospital. Mrs. Rankin, despite everyone's efforts, had died of a heart attack.

That night was a strange one for me as I sat home thinking about the delicate and unpredictable nature of life. How could someone who I had just spoken to, someone who seemed to be a permanent part of our neighborhood, be dead? Did we do everything we could have to help her? Was there something that made us go to the house to ask permission to fish on that fateful day? I shudder to think of what would have happened if we had not knocked on her door, as Mrs. Rankin seldom had visitors. It was all very confusing at the time, but I am convinced that Rich and I were called to the Rankin house on that day by God or angels, and I find comfort in the fact that, while Mrs. Rankin's life could not be saved, at least she did not have to die alone.

LURES

Serendipitous good fortune often prevailed during the most unexpected times. Little events in the eyes of a child could suddenly become the focus of the entire day. Such is the experience I had while walking up Lloyd Road one day with my friend Rich. It seems as though only a small number of cars used our road on a regular basis, and most of those that did were driven by neighbors. As a result, we often played on and along the edges of the road without having to worry too much about our safety.

One day, while running up and down the embankment by Rich's mailbox, our eyes suddenly fell upon a handful of colorful fly-fishing lures. Apparently having been lost out of the window of a passing car, this find, to a couple of young boys who did their share of fishing, was nothing less than absolute gold. Of course, collecting these flies served to spark our interest in finding more treasure, so Rich and I started an exhaustive search of the area's entire roadside. We soon found that the initial group of lures that we had discovered was only the tip of the iceberg, and there were more for the taking if one was diligent enough to look under the clover, goldenrod and other plants along the side of the road. It was the Yukon gold rush revisited, with each of us hurriedly claiming sections of the road as "ours" and meticulously searching every square inch of the banks for more rewards. Occasionally, the silence would be punctuated by exuberant shouts of excitement when one of us found more lures. Each individual celebration made us more and more determined and whipped us into a frenzied search.

Without realizing it, our day had been transformed into a treasure hunt, which culminated in a detailed and exacting arrangement and display of our windfall on Rich's back patio, and it wasn't long before we had plans to test the effectiveness of our collection at the neighborhood ponds, with the fish being the unsuspecting victims of our good fortune.

A CANDY EXPEDITION INTO TOWN

It was summer, glorious summer in Bernardsville, New Jersey, and we were out of school. It was the early seventies. The world was abuzz with the changing news of the time. *The Exorcist* and *Jesus Christ Superstar* were new, big sellers. The first hand-held calculator carried a list price of $249.00 while the cost of mailing a first class letter was raised to eight cents. The voting age dropped to eighteen, hot pants were in, Nixon was going to China, the Vietnam War was dragging on and bumper stickers read, "Clean Air Smells Funny."

At the bottom of Round Top Road, which is just slightly more than a mile south of Somersetin, and amidst the backdrop of these events, walked three boys, seemingly oblivious to the restless world around them, for they were on a mission. Bulging pockets jingled with change as Scott Pfluger, Jim Brown and I made our way from Scott's house, through the cool shade and along the stone walls of Olcott Lane and across the open, hot pavement of Claremont Road where we could finally see our target: Karl Jerolaman's Store.

Now, Jerolaman's Store was, and continues to be, a curious place of business. With its worn, wooden flooring and practice of selling everything from detergent and Popsicles to hard liquor, it was a quick, one-stop paradise for household items. But we were after one thing and one thing only: candy!

The old-fashioned, glass-fronted candy case held a cornucopia of confections, but we all had our favorites. I liked Tootsie Rolls, Jim was particularly fond of Smarties and Scott, well, Scott divided his allegiance between Bit-O-Honeys and red licorice. And it was all spread out before us and available for pennies apiece—provided you found favor in the eyes of old Mr. Jerolaman. This man was a fixture in our community. Aside from having established himself as a business owner, he also volunteered for many years as a member of the Bernardsville Fire Company and could always be seen cheering on the Bernards High School football team at their games. But Mr. Jerolaman had a unique reputation among the resident children. There was a specific way to act in his store and a particular manner in which to pay, as I was about to find out. Ours was not going to be an easy mission. One false move and our sweet dreams might go down in flames, but our challenge was one we willingly accepted. Scott, however, filled our time and allayed our concerns during our travels by telling stories that kept us in stitches, for he always had, and continues to possess, an extraordinary ability to bring happiness and laughter to any gathering.

Eventually, we reached Jerolaman's. Approaching the front stoop of the store, we each took a moment and privately counted our change. This was it. We knew we were dead in the water if we ordered more than we could pay for. At last feeling secure in the knowledge of our limited wealth, we opened the screen door, which sounded its familiar *squeeeeak*, and stepped inside. *Bang!* Having completely forgotten about the spring on the door, we had foolishly allowed it to slam closed behind us. This was not good! We were barely in the door, and already breaking protocol, had managed to chalkup our first possible strike against us.

Meanwhile, standing behind his hand-crank cash register, Mr. Jerolaman scrutinized us, one eyebrow raised, as we slinked up to the candy case.

Jerolaman's Store.

Pretending to act casual, we paused and surveyed the neatly aligned boxes of treats behind the glass before deciding to ask for help. Finally, Scott asked whether it would be all right if we bought some candy, please? There was silence. No response. Had he heard us? Did we dare ask him again? Scott shot me a look of quizzical desperation that made me chuckle out of nervousness. "Oh, no!" I thought, "Strike two?"

Mr. Jerolaman looked up over the counter, then looked down again and replied sternly, "What do you want?"

A good sign, I thought. At least he was acknowledging us.

Scott answered him by saying, "If it wouldn't be too much trouble, we'd like to buy some candy, please."

"All right, all right!" growled Mr. Jerolaman as he slowly rose and made his way to the case, eager and inspired, I'm sure, to make his multiple-cent sales!

One by one, we sheepishly ordered our favorites, and one by one, we watched while his hand, minus some fingers, picked out our selections and dropped them into small paper bags. All that was left to do was pay. Jim was first: silver coins, a good move. Then Scott: silver coins, with quarters, another very commendable move. Apparently, everyone knew that Mr. Jerolaman hated to count pennies for candy sales—everyone, that is, except for me. In this instance, I had the misfortune of living one to two miles away from the center of town and had not acquired the street smarts like my two friends who lived just up the road from the store. So when I dumped my pile of pennies and a few nickels on the counter, a hush fell over my two friends.

"What is he doing?" Scott must have thought. Jim just stood with his mouth open. A long, pregnant pause ensued. Luckily, we must have either caught him on a good day, or he had decided to give the "new kid" a break because Mr. Jerolaman only shook his head and gave me a lengthy, second glance before sweeping the copper change off the counter and dropping it in his drawer, much to our great relief.

After the sale was completed, we shot out the door, leaving it to slam again, I'm sure, and hurried down the sidewalk to sample our successful purchases.

"Man, I can't believe he took your money," said Scott. "I've seen him throw pennies across the store and yell at other kids."

Then Scott smiled and stuck a licorice between his teeth. We were home free, and what better way for three friends to spend a summer's day than in each other's company? We had not a care in the world that afternoon as we made our way back along the roadside with our sacks of sweets, living life, telling jokes and laughing, always laughing.

Fighter Jet

The neighbors, who lived up the hill from us when I was very young, were a wonderful family that my parents and I got to know quite well. The father was a pilot, and in the late 1960s, was preparing to leave the armed forces for a career as a commercial airline pilot. On his last day of military flying, he notified us to expect a surprise visit from him sometime during the day, as he planned to fly over our homes. Well, I was excited at the prospect of seeing a military jet in flight and prepared for the event by readying my binoculars and keeping a close watch on the skies.

At the time, there was not as much air traffic over Somersetin as there is today, so it was pretty easy to keep track of planes over our house. There was a progression of propeller powered airplanes, some private and some commercial, and every now and then a commercial jet would soar high above the clouds. Still, I waited patiently, wondering how good a view I would get of the fighter plane.

Sometime during the mid afternoon, we heard a low-pitched, thundering sound approaching beyond the hills to the northeast. Running out into the yard, I could not spot anything in the sky, although the sound was getting louder. I stood and wondered why I couldn't spot the plane. If it was my neighbor, where was he? Perhaps he was flying so fast that the sound was trailing far behind him, and I had missed him. Perhaps, despite the noise, he was too high to see.

Then I was stopped in mid thought by a sight that excited every fiber in my young body, a sight that I had never seen before, and a sight that neither I nor Somersetin may ever see again. Emerging from the horizon was a camouflaged, F-4 Phantom II fighter jet with triangular wings flying lower and faster than I could imagine. It seemed to be just clearing the tree tops and streaking directly toward my house. The sound increased, louder and louder. Suddenly the whole earth seemed to rumble under my feet with a sudden roar as the jet growled over my house and me, and it seemed to clear our oak tree by one hundred feet or so. I imagined what it must be like on the battlefield as I rolled over and over on the grass, pretending to be a soldier. The noise of the jet increased after it passed, and the twin jet engines propelled the craft higher up into the sky, leaving a slight trail of heat waves in its wake. Watching the flight path of the jet, I was in awe of the power of the machine.

It continued on a straight path and then turned off to the south. Soon it was in the northeast sky again, and I realized he was coming in for another pass. I readied myself on the lawn, holding my hands over my ears to deaden the roar of the engine. Again it thundered overhead, and I

remember lying on my back, engulfed in the moment, seeing the numbers and camouflage on the wings and fuselage, and then hearing and feeling the deafening roar of the afterburners. Slowly, the noise of the fighter jet faded into the distance.

That night, when my neighbor came home, I watched his headlights move up the driveway to his house. I remember thinking about the power of my experience that afternoon and the amazing control he had of his aircraft. It wasn't much later that he and his family moved away to California due to his new civilian aviation job, but I will never forget the gift of memories he gave to me on that summer afternoon.

Redcaps

My father was a botanist and a professor at Fairleigh Dickinson University in Madison, New Jersey. He was a man who treasured his solitude and avoided crowds of people like the plague. Sports were not of major interest to him, so we didn't spend a great deal of time tossing a football or playing catch with a baseball and mitts. However, he filled our days with other endeavors, and the time he spent with me as a child often involved many nature-related activities.

One particular event that sticks in my mind was collecting samples of mosses and lichens that grew along the southern banks of Lloyd Road, past the first two bridges and the power line trail. He pointed out to me the different types of plants and one particular species called British Soldier Lichen, which is commonly referred to as Redcaps. Scattered throughout the masses of low, lush, green plants were tiny stalks that grew out of the lichen's gray-green bed. Atop each stem sat a cap of brilliant red, which gave the appearance of the uniform, especially the hat, worn by a British soldier during the Revolutionary War—and if this resembled one soldier, a battalion of them lay at my feet. This type of plant can still be found today on the banks of Lloyd Road. I do not know why this image has remained with me, but it is a wonderful example of how the imagination and the environment can come together to produce a lasting impression.

Cake Artistry

Both of my parents were artistic, but my mother is one of the most talented and creative people I know. One particular gift she shared was the ability to carve and decorate cakes as good or better than any professional I have

seen. From birthday cakes to wedding cakes, she has done them all. Some of her cakes were architectural models. Others were whimsical works for children, and her talents were always in demand.

As a child, my birthdays were punctuated by fantastic cakes that were carved and decorated to resemble whatever I wanted. In the early years there was a merry-go-round, a train cake and a fire engine. Each was carved, iced and decorated to look very close to the real thing. My mother went on to create wedding cakes, eventually including my own, with incredible filigreed details and hand-painted flowers of hard royal icing.

Ultimately, her talents resulted in her creating architectural cakes. One of them was a replica of the Somerset Hills Lutheran Church in Basking Ridge, New Jersey, which was made for a tenth anniversary celebration. However, her crowning achievement was a replica of the historic Ford Mansion, complete with windows, shutters and a "stone" foundation, that was made for the Morristown National Historical Park in Morristown, New Jersey. Made in 1972, the architectural cake model and the landscaped sheet cake base upon which it rested served five hundred people and commemorated the centennial celebration of the National Park System. The event was held at this location because Morristown National Historical Park was created in 1933 and designated as the first national historical park in the United States. The Ford Mansion, also known as Washington's Headquarters, in Morristown, New Jersey, is part of Morristown National Historical Park. During the Revolutionary War, Mrs. Jacob Ford Jr., who was a widow, lived here with her four young children. They opened up their home to George and Martha Washington and the general's staff officers, who arrived in a storm of hail and snow on December 1, during the hard winter of 1779–1780. This was the finest home in Morristown at the time, and it served as Washington's headquarters while his troops were camped in nearby Jockey Hollow. I'm willing to bet no one at the time thought the home would be rendered into a confectionary masterpiece!

Even the newspapers covered my mother's incredible work. The comment that everyone had was, "It looks so real!" Upon closer inspection, people would realize that everything on the cake was edible except the trees and shrubs. Here's where that extra dose of creativity kicked in. Candy coated nuts were used as rocks. What looked like grass was really finely chopped and colored coconut. Pulverized cookies became dirt, and hard royal icing, duplicated on templates, became window shutters and mullions complementing hand-painted windowpanes. After a while, I believe it became a matter of pride that she put only edible decorations on her cakes, and she always found a way to beat any challenge.

Transporting the carefully crafted confectioneries to their ultimate location was a tricky business. My father's station wagon became the delivery vehicle, and my mother was very careful in positioning the cakes, so they wouldn't slide around the back of the car. Occasionally there was the loop of icing that drooped or a flower that got damaged by a misplaced finger, but it was always repaired with precision. My mother took many of her tools and icings with her, just in case they were needed for touch-ups. The ones she brought were but a few of the many bags, tips, knives and other instruments she stored in her decorating cabinet in our basement.

I delighted in watching her work, partly because I got to lick the icing bowl and eat the discarded carvings of the cake, but I also enjoyed it because my mother seemed to be creating magic. Her hands made everything look so easy, yet whenever she let me try, I was reminded of just how much skill it takes. Making a rose was always the biggest challenge for me. I would try repeatedly, but like any art, it takes a great deal of practice to do it right. My icing roses always looked like pine cones, but even these could be magically transformed into a flower with her attention.

I never got in her way, except for once. I was watching her put the final decorative touches on a cake at our dining room table one afternoon. At the same time, I somehow found it necessary to juggle a football in my hands. I remember my mom warning me about playing with the ball around the cake. Her words were still hanging fresh in the air when it happened. I fumbled the ball. Slow motion camera work would pale in comparison to the length and horror of that moment in my mind. My football—the one that got kicked in the grass and the mud and got stuck under our porch and manhandled in all our neighborhood games—was flipping end over end toward the cake. In my mind it took an eternity, but there was nothing anyone could do. I closed my eyes. No one had reactions quick enough to prevent the inevitable. *Plop!* That was the sound that hovered in the silence of the room.

Did I tell you my mother is a very patient and understanding woman? Well, she proved she had both self-control and crisis management skills that day. I was sent out of the room, iced football in hand, and while I washed the icing off of my football in the kitchen sink, I was sure the cake was ruined. To my amazement, my mother not only repaired the damage, but I couldn't tell where the imprint of the football used to be. All was forgiven, the cake was a huge success, and my mother still let me watch her work— without my football, however.

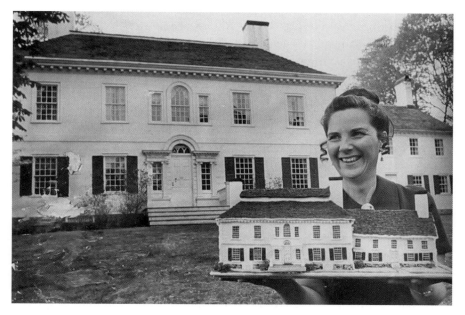

Mildred Ward in 1972 holding her architectural cake replica of Washington's Headquarters.

JAZZ

My love of music came from my father. While he painted and dabbled in woodcarving, it was music—jazz music—that held a fascination for him. My father owned and played several instruments. There was the Selmer clarinet, which was eventually handed down to me, an alto sax, baritone saxophone, flute, a ukulele and even an antique banjo. However, his favorite instrument was his tenor sax.

In the evenings, my father would carry the saxophone case to the corner of the dining room and go through one of his favorite rituals of preparing the instrument for use. I can remember him greasing the cork, attaching the neck strap and soaking the reed in his mouth until it was pliable enough to fasten to the mouthpiece. Then he would warm up his fingers, and this activity produced a clicking sound unique to the keys of this instrument as they were depressed and released.

It was understood that this was listening time, and I was not to disturb him with questions, although my father would always share with me his admiration for the jazz musicians and selections he respected most. There was Billie Holiday singing "God Bless the Child," Dizzy Gillespie playing "Salt Peanuts," John Coltrane, Coleman Hawkins, Charlie "Bird"

Parker, Benny Goodman and Lester Young, whose first name became the inspiration for my brother's middle name.

I would invariably sit in our living room, or better yet, under our dining room table while my father turned on our stereo and tuned in to WRVR-FM, a station that broadcasted from New York City. The show that sticks in my memory the most was always introduced with the announcer saying, "Just Jazz, Ed Beech with You," and while the deejay played the records, my father would improvise on his tenor sax, eyes closed, soaking in the music as the melodies intertwined with the soft, feathery tone of his instrument. Gold and silver, man and instrument, live performance and recorded standards, amateur musician and professional masters of their art blended together, filling our house with music.

My father was not a professional caliber musician, but he was an accomplished woodwind player, and when he played, it was the most relaxed and passionate state in which I can ever remember seeing him. He played, and I listened, and somewhere in there, somewhere in between the notes, lay a message that reached out to me—it was the revelation that there was more to music than black notes on a lined, white page. This was music that came from somewhere deep inside. This was music that sprang from the soul.

Feldmann Addition

As Rich's family grew, the Feldmanns decided that they needed more space. With three children, their second floor, which once served as Chester and Hannah Wilder's apartment during the estate years, was just too small. The bedrooms were tiny and were not conducive for play, study and storage of the children's items. The solution was to raise the roof along the back of the house and build a second floor addition.

This was my introduction to building, and Rich and I helped his father and the builders on the demolition and construction. At the age of twelve or thirteen, this event was a milestone, a coming-of-age activity that validated our ability to be of help on a "real" job. We started doing little things, like hauling old shingles away in wheelbarrows, and grew to handling larger responsibilities such as moving two-by-fours and taking measurements.

Eventually we were allowed to hammer the studs into place, which took a great deal of practice and patience. Remember that this was before nail guns were as commonly used as they are today. At first it was frustrating, especially when we could see the professional builders drive the nails in with three strokes of their hammers. We bent about every other nail and missed the nail with many swings, but slowly and surely we made progress.

To do the job right, one needs the correct tools. One day Bill Feldmann presented me with my own new hammer that he had purchased for me. I was extremely proud of it and still have it today. It's funny how certain gifts can lock a person into a particular time and place. That's the way it is with my hammer. Since that day, I have used the hammer to build a house of my own, and every time I reach for it, I remember my godfather, his special gift to me, and my first experience of working side-by-side with adults.

The Attic Space

Before the addition was added to the Feldmanns' house, Rich and I had a secret place, or perhaps I should say a secluded place, in his house where we could go to escape the world and our younger siblings. The second floor addition forced the destruction of this little oasis, but I recall it well.

Tucked underneath the rear left gable and above the patio was the entrance to an attic room. As far as I can remember, it was only accessible from the outside by climbing a ladder to a small window through which we would crawl, as it conveniently swung open and closed on side hinges. We didn't visit this place often, due to the fact that we had to get permission from Rich's parents to use the ladder, but when we did, it was magical. Lit only from the small amount of light, which filtered through the little, diamond-paned window, the room was dark and the dusty boards of the subfloor added to the mystery and sequestered nature of the space. Sometimes Rich and I would bring comic books up to the room for our reading pleasure. At other times we would arm ourselves with pencils and paper and draw macabre, Charles Addams characters that combined the mysterious and the comical with a slightly skewed view of the world. Later in life, Rich's passion for cartooning would lead him to create cartoons for magazines and greeting cards, but his talent saw its beginnings in this cloistered area. More times than not, it was very warm—as this was essentially an uninsulated attic space—and we would not spend long amounts of time in the room before longing for cooler air.

Just what the original purpose of this room was, I cannot say. Certainly the door was too small to fit hay or other feed through the opening, but perhaps there used to be another access to the attic. I am quite sure it had a purpose at one time, most likely for storage. Otherwise, I don't know why there would be a working window. All I know is it was a perfect place for boys to play, and this might have been its best use of all!

Spook House

It was easy to imagine someone or something watching and stalking you while in the woods at dusk. Every crack of a stick invited a delightful, nervous feeling in the pit of your stomach, and you found yourself walking faster and faster to escape the unknown shadows lurking behind the trees. It was a common sensation one got in the woods in this area, and one day Rich and I decided to monopolize upon the situation.

Using a good deal of resourcefulness, we decided to build a haunted trail, which we called a spook house, among the paths and clearings we knew and had made in the woods across Lloyd Road. Planning was not taken lightly, and we sketched, measured, collected and manufactured for days. Routes were examined to develop a path that would generate the best effect for the scenes and frights we had in mind.

Once the route was finalized, we set about collecting the implements of terror. Old bed sheets were a popular item, as they could be used for ghosts. Twine, boards, nails, hammers, permanent marking pens, rubber gloves and old clothes were gathered into quite a sizable stockpile. Of course the bones we had collected from the sunken foundation site and the chicken coop were perfect additions as well.

Ghosts were made quite easily by stuffing material into the middle of a scrap of sheet, tying it off to represent a head and drawing large, black eyes on it. These were placed in unexpected places, usually crotches of trees, and connected to strings, which, when pulled from our hiding places, sent the ghosts frightfully flying across the path of the visitor.

Boards were laid across depressions in the ground, and rubber gloves were stuffed and placed in positions to simulate hands reaching up and out of the "quicksand" below the plank bridge. Of course, ominous warning signs preceded the bridge and were scattered about the spook house path to forewarn visitors of impending doom.

The Devil's Chamber was a highlight of the spook house and provided a change from the otherwise linear nature of the route. Created in a clearing we made off to the side of the path, it was about ten-feet square and walled with sticks and branches. In it we hung animal bones and skulls, also accompanied by signs fashioned to frighten the bravest of children. At the entrance to the Devil's Chamber was a gate that Rich and I fashioned out of branches and twine. Made to lift up and down with ropes, we would suddenly lower the gate when the visitors were inside the chamber. On the inside were a devil mask and an assortment of bones. After thirty seconds or so of "confinement," Rich or I would pull the gate up and allow the visitors to continue on their way.

"What are you talking about? I didn't put a mummy on the haunted trail!"
This cartoon by Richard Feldmann was created for Spook House.

For effect throughout the route, we would hang black threads from overhanging branches, which felt like spider webs to an unsuspecting passerby. Occasionally a rubber spider or bat would drop down by means of strings and dance in front of people's faces.

The *coup de grace*, however, was our proudest achievement and created the most macabre and unexpected fright of all. Hidden about ten feet up in a tree was a dummy we had made out of old clothes. Clad in blue jeans, a red and black flannel shirt and old sneakers, the dummy had a floppy head that Rich and I had made by stuffing a rubber mask. Hands were fashioned from stuffed old gloves.

I'm sure in today's world there would be psychologists who would have a field day with this whole scenario, but I think they would find special interest in the following account. The idea was to simulate a hanging, but alas, any rope we tied around the dummy's neck succeeded in pulling off the head, so we did the next best thing. One end of a rope was fastened underneath the arms and around the chest portion. This, at least, approached the desired effect and insured that the dummy would remain in one piece. Searching for the perfect spot, the dummy was hidden just above the quicksand bridge. The other end of the rope extended over a branch, which loomed above the trail, and terminated in the woods just slightly out of sight of the bridge. The results were fantastic, as the dummy was easily pulled off the branch to swing down and dangle in front of people.

We delighted in the fact that we could actually scare adults with this prank. One of the adults most surprised by the dummy was my Great Aunt Ella. After an abundant amount of coaxing, she had conceded to visit our spook house. Gracious woman that she was, Great Aunt Ella made her way through the paths rather gingerly and eventually approached the hanging spot. Not being able to see the bridge clearly from our hiding place, the rope was pulled too late, and the dummy swung down, hit and embraced my sixty-four-year-old relative from behind. While she was not hurt, my great aunt let out a shriek that I can still replay in my mind. Of course, we thought it was wonderful. Great Aunt Ella did not have quite the same impression, but she took it like a good sport.

All in all, the spook house was quite an operation. Rich and I were very busy scampering around to different hiding places and pulling various ropes and strings while the visitors passed. We were proud of our creation. Our family members were the most common visitors, often coming through twice in a row and complimenting our efforts. We even had a sign on the road offering spook house tours for ten cents per person. Some people did stop and visit—a big deal to us—but the bulk of our performances were given for family, neighborhood children and friends. Within our short time in the spook house business, I figure that Rich and I made about a dollar fifty each. We probably spent the money on Popsicles at Jerolaman's Store in town, but the intangible profits in creativity and enjoyment were extensive, long lasting and even sweeter.

Today there is a single family home that sits on the site of our former spook house. It is odd to think of a family having breakfast in a modern kitchen on land once occupied by our Devil's Chamber. Change is a constant, and the spook house is now part of the wooded area's history, the tides of time having washed away all physical reminders of our macabre creation.

8

The Unexplained

When the bright lamp is carried in,
The sunless hours again begin;
O'er all without, in field and lane,
The haunted night returns again.

—Robert Louis Stevenson, "North-West Passage,
1. Good-Night"

SETTING THE STAGE

Who doesn't love a good ghost story? They give us that uneasy, excited feeling, make us hold our breath and force us to take sideways glances to check the dimly lit corners of our surroundings. Ghost stories are fun, and many of them indirectly divulge historic facts and feed us information in a manner that makes history lively in a very unique way. They are one of the spices of an area that infuse a landscape with flavor and character. This is the reason I have included these tales in this book, for they are a part of the area's lore.

Make no mistake about it; there is a pervading energy that moves within and among the houses of Somersetin that has the ability to make a definite and distinct impression upon its residents. I once heard this feeling summed up in the saying that "the air was busy with more than human visitors," and I believe this to be true.

Ghosts? Spirits? Well, I won't go so far as to suggest the existence of these entities as most people would define them is undisputed fact, but I can tell you that many unexplained events have occurred here. My opinion is that there is a link with the past that cannot be denied. There is something more

Former Fountain at
The Maples.

permanent than human life that pervades our grounds and homes. So, the question becomes, what is a ghost? To label unexplained phenomena as ghosts creates immediate mental images that have been developed, crafted and impressed upon us by gothic writers and Hollywood filmmakers. Some people believe ghost sightings to be contact with entities that are from another realm, or somehow trapped on this earth, and have not "crossed over" after death. Others think they are pure fantasy, or the result of our minds playing tricks on us. Still, there are those who take a more scientific approach. Perhaps there are emotional impressions on structures and atmospheres, some energies that we cannot yet measure or quantify but that may be explained through science at some point in the future. After all, is anyone so bold as to suggest we know everything there is to know about the workings of this universe? Remember that the preservation of the human voice on audio tape is a relatively new ability. A mid-eighteenth century audience would have thought this proclaimed ability to be absurd, and the same proclamation to an early seventeenth century audience might have resulted in one's own accusal and execution as a witch.

Ultimately, everyone must decide for themselves how to classify experiences of this genre, so I will report on these pages that which I know and leave the task of categorization up to you. But what if you encountered some stories that were not the work of some writer's fanciful imagination? What if you lived in a house and walked on grounds that played host to their own mysterious events? What would you do if these types of events came not from the pages of a fantasy book but from your own neighborhood and your own life? I never went looking for unexplained phenomena when I was young, but for some reason, I have been fortunate enough to witness and hear of many occurrences that stopped me dead in my tracks and left me searching for acceptable explanations. My godfather regards the ability to witness unexplained phenomena as a gift, and perhaps it is. If so, then it is one I would like to share with you.

While I can recall a number of distinct experiences for the pages of this book, I don't want to give anyone the impression that my former home or neighborhood was a hotbed of paranormal activity. It was not. After all, most of these stories and experiences were collected over a time period of twenty-four years of life in Somersetin. Things did not necessarily happen every day, every week, or even every month, but when they did, they were memorable.

In between events there were the usual noises that old houses make. The steam radiators, loose windows, wood frame construction and settling enabled the house to have a repertoire of sounds that could be heard 'round the clock. The point I'm making is that when one lives with these sounds on

a daily basis, it becomes easier to identify those that are unique, those that are strange and those that cannot be categorized under the normal headings of explanation.

The following events are a collection of personal experiences and accounts from other respected individuals. They are enjoyable to read and might make one think about a realm beyond our physical existence, a realm that may sometimes become entangled with our own and may contain entities and energies that, to this day, may have their own, inescapable bonds to Somersetin and the areas in which we all live. Whether you regard their causes to be ghosts in the classic sense, scientific anomalies, flights of the imagination, or something altogether different, these reports are included because they add to the character of the area and preserve bits of its history. If nothing else, these stories will round out the unique sense of place that makes Somersetin extraordinary.

Guardian in the Doorway

My introduction to unexplained phenomena occurred when I was perhaps five or six years of age. As I have mentioned earlier in the book, my family consisted of my two parents, my paternal grandmother and a brother who was still in a crib at the time of this first story.

As in most families, there is a bedtime routine that establishes itself fairly early. One of the traditions I remember was that my mother would always come in to kiss me and tuck me in for the night before she went to bed. Being a light sleeper, I would usually wake up during this routine, and in fact looked forward to it. Truth be told, I often found it difficult to drift off to sleep until after my mother's nightly visits. I guess I liked the reassurance of knowing that my parents were near.

My room was off the upstairs hallway and three rooms away from the bathroom. To make it easier for me to walk to the bathroom or my parents' room during the night, there was always a light left on in the hallway at the top of the stairs. Night after night, my mother would visit and perform her maternal ritual before setting off for bed.

On one particular night my door opened, and I saw the silhouette of a woman, who I assumed to be my mother, standing in the doorway. I could not make out any features because the night light in the hallway created only a dark shape from my perspective, one that presented the image of a person with hair piled up on top of the head and wearing a dress or a robe. The figure did not move, and after several seconds, the door closed. I remember noting that I never saw the figure actually close the door, and assuming the

figure to be my mother, I also remember feeling disturbed that my mother had not come in to say goodnight.

I listened intently after the door closed, waiting for my mother to either walk away on the creaky floorboards of our hall or reenter, but nothing happened. Bothered by this, I climbed out of bed and opened my door, expecting to find my mother on the opposite side, quietly standing guard and listening to see if I was awake. To my surprise, I found no one in the hallway at all. The house was silent, and I crept past my grandmother's room where she lay sleeping, the floor squeaking under my weight, and continued through the hallway to my parents' room. Peeking my head into their room, I found them both asleep in bed and woke them up to ask why they had not said goodnight. Apparently, my mother had been in much earlier and had been asleep herself for several hours already.

My parents were perplexed by what I had seen, but it was very late, so we did not stop to ponder what I saw at my door that night. Instead, I was led back to my room and tucked into bed, and I thought only occasionally of the incident until I was a bit older and began to view this incident as a prelude to other unusual events that occurred in and around the house.

Stairway to Mystery

During my years at my childhood home, I often lay in bed, long after others were asleep, and listened—listened to the sounds of the house as they mingled with the sounds of the night outside. Most sounds I could explain or identify, but there was one, which occurred quite frequently, that I could identify, yet not explain. The sound was one of muffled conversation coming from downstairs. It was impossible to make out individual words, but several different voices could be heard conversing and talking as people might around a dinner table or during a small party. The voices never got loud, and I would not consider them to be whispers, but they were there.

So intrigued with this sound was I that several times it led me to get out of bed to investigate. With the rest of my family asleep, I conducted many experiments with this phenomenon, trying to find its source. The soft conversation was audible from my room and could be heard from the hallway. Standing at the head of the stairs, I peered down into the dark, wondering what it was that I was hearing. As much as I tried, I could never decipher any words, but this much I do know: the sound stopped immediately when I began to descend the stairs.

This was a fairly common sound, and since it was unwavering in its intensity and character, I came to regard it as a curiosity. It inspired no

fear on my part and was heard by other members of my family as well. My parents explained it away as the sound of the wind, but never in a convincing fashion.

I learned much later on that Mr. Lloyd once had a habit of paying a visit every weekday morning at ten minutes after seven to roam through the kennels. If the weather was bad, he would sit in the kitchen of this cottage to discuss dogs with the Hankinson family. Was my family hearing remnants of these old conversations, preserved somehow in the atmosphere or structure of the house, or was it only the wind after all?

On many occasions at night, noises could be heard on the stairs themselves. Sounding exactly like footsteps, these noises would ascend the stairs but stop on the top tread. I remember lying in bed knowing that old houses creak and have perfectly natural, explainable noises that give them character. As a resident of an old home, no one had to tell me this, but my experience in the old home also made me acutely aware of the source of these creaks, cracks and squeaks.

Every floor and every tread on the stairway had its own, peculiar noise that it would make when bearing weight, and this is the point that baffled me with these night sounds. You see, while I could pinpoint the location of the sounds, I could not always explain the cause, for the stairs often creaked in order from bottom to top. It sounded exactly like someone climbing slowly up the stairs, yet when one watched, no figure was ever there to be seen.

Unseen Eyes

My former house had an emotional aura best described as a weight or a pressure. Do you know the feeling you get when someone is looking over your shoulder? It was very similar to that, not tangible but very real and significant nonetheless. The feeling at the house was never malevolent, but it could be uncomfortable and sensed. The second floor especially of our house exuded an uneasy sensation, like something was monitoring your every move and watching, always watching. Even Norman Hankinson mentioned in his writing that he and his sister, Edna, were not particularly in favor of going up the stairs alone. It was a feeling with which I never became comfortable, and I can still recall the sensation to this day.

We had only one bathroom in the house. It was located at the head of the stairs on the second floor, which also contained all three of our bedrooms. Consequently, this resulted in many ascents up to the second floor during the day and evening hours. Going up, especially in the daylight was not so

bad, but the evening hours seemed to add an entirely new feeling to the experience. The uneasiness started to creep in as soon as one broke the plane of the second floor space, and once in a room, one could dispel the feeling by closing any room's door and turning on some brighter lights. Going down the stairs was done with a sense of urgency and alacrity, as if the air pressure itself were forcing one down the stairs and boring into one's body with unseen eyes. I am not the only person to have had this feeling. Relatives, company at our home and many of my parents' friends had similar feelings, and my friends certainly spoke of sensing a presence of some sort that made them uncomfortable on the second floor.

This same feeling could also be felt outside the house at night. Living with only my mother during my high school and college years due to my parents' divorce, it was common for me to come home to a dark house late at night while my mother worked the night shift as a nurse. Parking the car at the top of the driveway meant a long walk around to the porch and in the door before light was available. The feeling of eyes watching you from the second floor was so intense at times that it would quicken my step and send a shiver racing up my spine that was only relieved by finally reaching the light switch.

A fear of the dark it was not, for no other location has ever affected me in quite the same manner, be it on a dark street at night or alone in a tent somewhere in the forest. In fact, the dark is actually quite comforting to me as a rule. No, the feeling produced at the house was not one I ever experienced at any other place. It was a singular, unsettling emotion, which was unique to the house, and one I never could explain.

Baffling Sounds and Mystifying Events

A number of strange, sudden and seemingly isolated events occurred while I was living on Lloyd Road. Some of these were the kind of things that would make you jump, and leave you startled and wondering what would happen next. I can say through experience that a few of the unusual phenomena that did occur were not unnerving as they were happening, but afterward, in the period of time immediately following the events, I became fully conscious of my environment, feeling as if every nerve in my body was attentive and ready to explode with anticipation.

One of the more startling occasions occurred while I was home alone in my room and studying very late at night for a college class. The house was quite still until I heard a horrendously loud, crashing noise coming from the kitchen. The noise was enormous, sudden, metallic and ceramic, sounding

as if the cupboards had fallen off of the walls and every utensil, plate, cup, pot and pan in the kitchen were suddenly pulled from their shelves and toppled to the floor.

I don't mind saying that this alarming sound made me jump and sent a definite chill through my body. To tell the truth, I didn't really want to see what had happened. Thoughts raced through my mind. Was I alone in the house? Had someone broken in? Should I stay put and listen for more noises?

After a minute's hesitation, I decided to go have a look. Turning on every available light on my way down the stairs and through the first floor hall, I finally reached the kitchen to find nothing. Not one pot, not one pan, not one piece of silverware was out of place. In fact, everything was in its proper location. Leaving the kitchen, I also checked the other rooms, even the basement, eager to find a cause for the tumultuous cacophony I had heard, only to find nothing unusual. I am certain the sound came from the kitchen. When one has lived in the same house for twenty-one years, it's not too hard to pinpoint the locations of sounds. This event left me very nervous and not too happy to return to my room and bed, all the while wondering, waiting and listening.

One other sound I could never explain was also the most disquieting. Thankfully, I only experienced this sound four or five times during my late teens and early twenties. It would occur late at night when I was in bed, having just turned out my light, become comfortable under my covers and closed my eyes. Without warning: *Wham!* I would be jolted upright in bed by a sound I can only explain as the sound a baseball bat might make if it were slammed against the wall above my headboard. My heart racing and accompanied by a huge adrenaline rush, it took me several minutes to calm down after these events. There were no pipes in the walls of my room, and my headboard was against an interior wall. I was left wondering what could have possibly made such a sound and whether it would be repeated.

At other times I would notice peculiar patterns of events that transpired. One such occasion took place when I was painting the iron railing that stretched along the edge of our raised concrete patio. I was approximately nineteen years old and working outside during a sweltering day in the summer. My mother was asleep inside as was usual because her night shift at the hospital put her on an opposite sleep schedule from mine. In any event, I had taken my watch off before starting work to insure that it wouldn't become splattered with the oil-based paint I was using.

Somewhere along the way I got thirsty and decided to take a break, get a drink and check on the time. The electric kitchen clock read 2:30 p.m., but my analog watch, which was on the counter, had stopped and read 4:28

p.m., almost two full hours ahead of the correct time. Not dwelling on this peculiarity, I went upstairs to find that an old clock in my room, the kind with the numbers that would change by flipping around, also displayed the time of 4:28. Although I found this coincidence to be very odd, I rewound my watch, reset it to the correct time, and thought little of the event until later that evening when I was looking for something in a box on top of my dresser. There, in a lower compartment, was an old silver Seiko watch that my father had given to me many years earlier. I had not worn it for over five years, so it was completely unwound. However, what caught my eye was the fact that its hands were stopped at exactly 4:28.

I thought of the slim chances of finding two watches and one clock stopped at exactly the same time and two hours ahead on the same day. It seemed a bit beyond coincidence, and I couldn't help but wonder whether the time of 4:28 held some significance of which I was unaware, and perhaps connected with the house.

The Figure in Black and White

There is an apparition that was seen in our house by two different people and on two separate occasions. On the first occasion it was witnessed by me. The second time it was seen by one of my friends.

Normally, when I was between the ages of eighteen and twenty-two, my schedule was rather consistent. I would commute to college during the day and arrive back home in the evening in time to greet my mother as she left for work at 7:30 p.m. After relaxing in front of the television or stereo for an hour or so, I would take out my books and begin to do the work for my college classes.

One night found me working on a sociology paper in the living room. It was approximately eleven o'clock in the evening, and the stereo was playing softly to fill the silence that permeated the house at night. I remember feeling suddenly chilled, and as I looked up from my work, I glanced straight ahead into the dining room and was surprised to see the figure of a man. He was standing along the right side of our table and not far from the doorway that led into the kitchen. Wearing a light shirt and dark pants, he remained in my sight for perhaps five seconds, looking very much like an image on a black and white television screen, and then simply faded from sight.

Those five seconds were the longest I ever experienced, and I can remember sitting riveted and peering into the now empty dining room. The event itself was not frightening, but I became entirely nervous that the apparition would appear again. Collecting my books and papers from the

coffee table, I headed upstairs to my very well-lit room and closed the door. Fear mixed with curiosity and amazement as I sat in the room replaying the event over and over in my head until I became too tired to stay awake. It was well into the wee hours of the morning when I finally fell asleep, with my room lights on!

About two weeks later, two of my good friends were home from college, and all three of us decided to congregate at my house to share college stories. I had not told either of my friends about my recent sighting, feeling a little fearful of their reaction. After all, how many people casually converse about actually seeing something like a ghost? As time went by, I was also doing a rather good job of trying to convince myself that I might have imagined the whole event. However, at one point during the course of the night, we were all standing and talking in the kitchen, as people tend to do. Suddenly I noticed that one of my friends, who was in a position to look directly into the dining room, was no longer engaged in our conversation and seemed to be looking into the dining room with a perplexed look on his face.

"What's up?" I asked.

"Is there someone else coming tonight?" he replied.

Noticing the quizzical look on his face, I told him that I wasn't expecting anyone else and inquired why he asked. His answer made my head spin.

"Because I just saw someone in your dining room," he said.

We all searched the house but found no one, and I didn't expect to. Our gravel driveway was about 300 yards in length, and cars could be heard long before they arrived at the house. Furthermore, our house was in a location that made it rather inconvenient to arrive by foot, and anyone entering the house through a door would have had to come in by the kitchen and would have been detected by one of us.

After searching the house, I pressed my friend to describe what he saw, and he described the figure of a man, which he saw for only a moment, with a light-colored shirt and dark pants moving past the doorway and out of his line of sight. That was it! I had to tell my story, and we spent several hours talking, speculating and theorizing about what we may have witnessed. We were glad to have each other's company, and I know I felt more secure being in the company of someone who had shared this uncommon experience.

As far as I know, these were the only times that this apparition was seen by anyone. Was it our imagination? If so, how does one account for the similarity in location and descriptions? Perhaps it was some kind of strange, atmospheric recording, and we were there at the right point in time to see it replayed. As for it being a ghost, I believe it is possible, and I don't rule it out. Ghosts are, after all, defined in many ways. In this case, I will probably never know for sure.

Levitation

One evening found me sitting in the living room with my mother and my girlfriend. All three of us were talking softly when a very uncanny sight distracted both women and held their attention in the direction of our enclosed porch. Being able to gaze across the hall, through an open set of French doors, and onto the porch, they saw first what I was only able to see after turning around in my seat. What we now all witnessed was an unbelievable event!

My mother had one of those plant stands with a center pole and a number of platters that radiated off from it. My girlfriend and my mother had both seen one of the plants in a clay pot lift six inches off of a platter and move several feet over to the right where we then all observed it hovering in the air for a few seconds. Suddenly, as if a string were cut from above, the entire pot then crashed to the ground, scattering dirt and pieces of clay pot across the floor. Had we not all seen this at the same time, it would have been difficult for us to believe, but there lay the remains a good three feet from its original resting place.

After picking our jaws up off our chests, we cleaned up the mess, although a bit too stunned to talk. This phenomenon would have been exciting enough if one of us saw it, but having three people watch the same event transpire lent a level of corroboration that could not be denied.

The Nocturnal Visitor

Of all the unexplained incidents that I experienced in our Lloyd Road home, none was more drawn out and unnerving to me than the one I am about to relate. It was a calm, autumn night during my college years, and as usual, I was alone in the house. As I remember it, the time was about 1:30 in the morning. I was up unusually late and reading in my bed. All was quiet in the house, and I was planning on settling in for the night in just a few minutes.

Out of nowhere, I began to hear the sound of someone walking on our outer porch, which led to the front door. I use the word "someone" because a biped makes an entirely different sound than an animal with four legs and feet. The wooden floor of the porch made that distinctive, hollow sound that I had come to know intimately. I tried to convince myself that my mother had come home early, but I knew that wasn't the case. I had heard nothing drive up the driveway, I had heard no car engine, I had seen no headlights, no garage door had opened and the footsteps were much too slow and heavy, sounding nothing like my mother's quick, light steps.

There was one long pause in the pattern of steps, but they soon continued to approach the front door. I tried to remember if I had locked up for the night. Yes, I had, but it brought little relief as I thought about someone breaking into the house. Frozen in my bed, I listened intently, hearing my heart pound inside my chest as the footsteps continued to the front door, and then stopped. I waited what seemed like minutes, although it was only thirty seconds or so, for the steps to resume, hoping they would walk off the porch. Our only telephone on the second floor was in the hallway just outside my bedroom door, and I thought about calling the police.

Slowly, I got out of bed and headed toward my door, which was open about a foot. At the very moment I reached the door, I heard the different and much more chilling sound of our front doorknob clicking as if someone were turning it back and forth. Then all fell silent. The fight-or-flight response had kicked in, and my respiration had increased along with my heart rate. I was not sure what to do, so I called out for my mother, hoping she had walked up the driveway for some reason and was fumbling in the dark for her keys. No answer. I called again. Still, no answer. Whatever was out there had not left the porch, and I was in no mood to make a move either.

Finally, after several minutes of stalemate, I reluctantly decided to investigate. I was still alone in the house. Whatever was on the porch was still outside, and I knew that if all the lights were turned off inside, I could move around undetected from the outside. Turning off my room light, I made my way out to the second floor hall, grabbing a broom for security. At the head of the stairs I turned off the only remaining light and plunged myself into darkness. I don't mind saying that I was terrified at that moment, and the fact that I was wearing only my underwear did not do much to bolster my courage. Willing my legs to move, I started to descend the stairs, one by one, walking on the two ends of the treads to avoid creaks, slowly counting the steps—eleven, twelve, thirteen—I eventually reached the bottom hall, only six feet from the front door.

Now I had some choices. Do I wait, or do I turn on the outside lights? The waiting was almost too much to bear, so I decided my best course of action was to go for the lights. Feeling my way to the light switch, I finally felt the cold, brass switch plate, bracing myself for whatever I may see on the other side of the door's glass. I took a second to check the button on the doorknob. To my relief I felt that it was still locked. This was it. I clicked on the porch light and looked outside. Nothing—nothing at all! How could this be? I had heard nothing walk off the porch! I turned on the flood lights and looked out the living room's porch windows. Still, nothing!

After checking the view out all the windows, I decided to open the door and peek outside to the end of the porch where I could not see from inside

the house. I know, I know, this is the point in all the horror movies where the overly inquisitive victim gets it, but it was the only place I couldn't see, and I *had* to know.

Still clutching my broom, I unlocked the inside door and turned the doorknob, which only minutes before I had heard clicking back and forth. Slowly opening the door, I gazed out through the screen door. Then I noticed something that made me go cold from head to foot. The screen door, with no clicking parts, was closed, locked and hooked from the inside. What I realized immediately was that no physical hand could have grabbed our inside front doorknob and turned it through the screen.

Staring out into the void of the cold darkness beyond the porch light, I decided I had had enough, closed the door, rechecked the lock and rapidly headed back to my room. Closing my bedroom door tight, I climbed into bed and sat with the light on until 2:30 a.m., just listening and waiting. Mercifully, I was eventually able to fall asleep and woke early the next morning, my room light still burning brightly.

To this day I wonder what it was that I heard in the early morning hours of that night. Where did it come from? Where did it go, and how did it turn that knob of our front door?

Mist and Footsteps

The house where I spent my life from 1959–1983 was not the only home on the former Lloyd Estate to have strange and unexplained stories associated with it. My godparents lived in the house that used to be the chauffeur's house. It was here that Chester Wilder, the Lloyds' chauffeur, and his wife, Hannah, lived in a dainty, second floor apartment that once included French clocks and the ever-present scent of Hannah's perfume. The first floor included the kitchen and the garage bays where Chester would maintain the Locomobile and the Rickenbacker limousines.

My godparents, Bill and Betty Feldmann, told many stories about their house, and I remember being totally absorbed by them. One story concerned the upstairs bathroom, which was situated at the top of the back stairs that led down to the kitchen. There was always a light left on in this room at night, and I was told it was for a very good reason. It seems, as my godmother told me, that on several occasions, not long after moving into the house in 1955, a light would be seen by night emanating out of the bathroom. Being at the opposite end of the hall, one of them would walk down the corridor to find a misty shape illuminating the room, yet every electric light in the room was off. I'm sure, being a bit unnerved by this occurrence, they

got into the habit of leaving a light burning in the bathroom every night, which seemed to solve, or perhaps mask, the spectacle.

Another tale that my godparents told, relating to this phenomenon, concerned the sound of phantom footsteps—an event that would be heard and repeat itself from time to time. In the middle of the night, one or both of my godparents would be awakened by the sound of soft footsteps walking down the hall. Eventually, they would enter their bedroom and stop at the foot of their bed. Due to what I'm about to tell you, my godmother would often be too shaken to look until, after a short intermission, the footsteps appeared to exit their room and continue down the hallway again.

When investigated, no figure could be seen in hall, yet the soft footsteps would continue the very length of the hallway, coming to a stop in front of a large, mirrored piece of furniture outside the bathroom and at the head of the back kitchen stairs. Most times the event would conclude at this point. However, on some occasions, the footsteps would be followed by the appearance of a column of mist that would slowly dissipate in front of the mirror at the end of the hallway. The sighting would often be accompanied by a sense of unwelcome sentiment, almost as if the apparition didn't approve of my godparents' presence.

Now, the Feldmanns did have three children, and as is the case with every good parent, there was the urge to check on their children after these events. Every one of their investigations resulted in the same outcome: all of the children were fast asleep, no figure could ever be seen walking down the hallway during these audible, nocturnal strolls and no explanation could be found to account for the column of mist.

Neither Bill nor Betty spoke of these events to their children until the day it was seen by another family member. Apparently, their youngest daughter, who was about eight years of age at the time, was trying to sleep in her parents' room when she looked down the hallway and saw a misty shape at the end of the hall. Hearing her daughter's frightened screams, my godmother climbed the front stairs nearest to her room, consoled her daughter and asked her what was wrong. When she was told about the misty form, Betty revealed that she, too, had seen the same phenomenon at other times. It may not have done much to diminish the fear, but at least it could be discussed, and that in itself was a relief.

The Voices of Children

As there were two schoolhouses that once stood on Lloyd Road at different times throughout the years, there are no doubts that the sounds of children

have not been a stranger to the area. Perhaps some of these sounds still echo through time, as suggested by this next story.

Betty Feldmann had an experience one day that she could not explain. She was brushing her hair in the lavatory located in their garage during the middle of a bright, sunny day. All of the children in the neighborhood were in school and the area, as usual, was quiet and peaceful.

Then something made her stop what she was doing and listen, for she heard something unusual. The more she listened, the more she was puzzled by the sound. It was the sound of children playing and laughing. Where was it coming from? Whose children could they be? As she stepped outside through the garage door, the sounds diminished and then dissolved to silence. Try as she might, Betty could not find any children or source for the sound she heard.

However, this was not to be the only time that she would hear these phantom children. On another occasion my godmother was out for a walk down Lloyd Road. As she was rounding the bend by the pond, she heard the sound of children's singing at the edge of the woods near the stream where there are no houses to this day. The area was flat and easily viewed, yet no one could be seen, and the voices soon faded away.

Again, there was no suitable explanation for the sound, but we did uncover an interesting fact. The point from which the singing seemed to emanate was the same location where the Somerset Inn School used to stand. This building was also used as a Sunday school for children, and I'm sure singing played a role in both situations. After these educational functions ceased, the building was dismantled, leaving only the old foundation and remaining memories to weather in time.

Chester

Without a doubt, the most intriguing report that my godparents told was one that was directly linked with the history of their home. On a bright spring afternoon, Betty was knitting on the couch in her living room. She was alone in the house with her children in school and Bill at work. After a while she had the distinct feeling that there was someone watching her, someone in the room. Looking up from her work she was able to gaze across the room and down a few steps into their sunken dining room. There, at the bottom of the steps, she saw a man looking at her, wearing breeches and a coat with a driver's cap on his head. He looked quite real, and tipped his hat to her. Betty stood up and asked if she could help him, but as she approached the steps to the dining room, the man simply disappeared.

Wanting to know who was in her house, she carefully checked the two floors of her home but did not find anyone. Shaken, my godmother felt that she had just seen a ghost because, as she reasoned with herself, men don't just vanish from sight.

This apparition would often appear to Betty when she was sewing, and it was quite unsettling to her. During one of these sightings, the apparition turned to its right and walked out of sight toward the kitchen. Betty followed, descended the three steps into the dining room, and looked to her left toward the kitchen just in time to see the man turn to his left and walk into the garage. At this point my godmother called out to the figure, but she received no response. Nervous but curious, Betty continued to walk into her kitchen and then into the garage. There she found the garage bay door closed, all the windows shut and locked, the cellar door hooked from the inside and no trace of the man.

Eventually, being so perplexed by these sightings, Betty recounted her experiences to my mother. After some thought, they came up with a possible explanation. Based on the apparition's clothing and the fact that the Feldmanns' house had also been the chauffeur's home for the Lloyd Estate, the two women theorized that perhaps what Betty had seen was Chester Wilder's ghost. The Lloyds' employees were known to be very loyal, and maybe he still felt he had a job to do and a responsibility to guard the house. My mother also suggested that he might not know that he had passed away or might feel grounded to the house.

If the story were to end at this point, it would still be an interesting tale, but it continues. Some time later, Betty was again sitting on her couch in the living room. It was a quiet day, and she was the only living person in the house. Without warning she looked into the dining room to see the apparition of the same man dressed in exactly the same attire. As he gazed in her direction and tipped his hat, Betty had the composure and presence of mind to address him. Believing the apparition to be that of Chester and feeling that he might be inquiring if she needed a ride, she told him simply, "Thank you. Your services are no longer required."

Immediately after she spoke these words, a sad expression fell across the visage of the apparition. The figure turned to its right as in the previous appearance, and passed out of sight. Again, my godmother rose and walked into the dining room. Again, she saw the image of the man turn out of the kitchen and proceed into the garage. Following as before, Betty walked through the kitchen and into the garage where she found herself, as before, alone.

But was she truly alone? Does Chester's ghost still feel a responsibility to remain on the Lloyd Estate? No one can answer these questions for

sure, but there is an interesting side note. Since my godmother relieved the apparition of his duties, neither Betty nor her other family members ever saw him again. It may be that my godmother helped Chester to move on to the other side, or perhaps his spirit still lingers in the house waiting to serve future owners.

Hardscrabble House Ghost

There are many old houses that sit on Hardscrabble Road in the area once called Logtown. Some date back to the early 1700s. These houses have seen their share of history, and it's no wonder that some of them are reputed to be haunted. One such house claims to have a ghost that not only likes to make appearances, but to throw things as well!

One evening the homeowners were hosting a dinner party for a group of friends. Everyone had arrived and things were going as planned, but there was an unseen guest that was in attendance that night. As the meal was being served, an invisible force removed a fork from one of the guest's hand and sent it darting across the dining room table. What's more, while the fork was in mid-flight, it changed direction, flying off at an angle until it hit the front door where it finally came to rest on the floor. "What just happened?" the startled diner remarked. The rest of the guests had all seen the event, yet none could offer a reasonable explanation. Minutes later, the hostess walked into the kitchen only to be welcomed by a cup that flew across the room right in front of her face and came to rest on the cutting board in the breakfast room! No one had thrown the cup, and the unnerved guests were then at a total loss of words. These were not isolated events experienced by one individual. On the contrary, these unexplained phenomena occurred within a very short time of each other and were witnessed by a house full of people.

As if this were not enough, two people have seen an apparition in this same home as well. On several independent occasions, a blue, misty shape has been seen hovering in one of the interior doorways. Both witnesses report that it resembles a human in stature and proportion but is not solid, and it appears to be slumped in a sitting position in the pass-through. There also seems to be an agreement as to what this apparition is and what causes the phenomena to occur. Knowing the area's history, those that have experienced the sightings and the other phenomena believe it to be the spirit of a Revolutionary War soldier. Many of them were camped in the area during the brutal and snowy winter of 1779–1780, and many of them did not survive to see the spring due to disease, starvation and exposure. While

it can be stated as fact that many of these soldiers never left Logtown, could it be possible that some of these American patriots are still on duty?

The Woman of the Old Forge Road

The remnants of the old Forge Road can still be seen in the Audubon sanctuary off Hardscrabble Road, barely suggesting its original northeasterly route toward what is now the Jockey Hollow section of Morristown National Historical Park. By day, the shadows hang thick under the trees that tower above this old path once traveled by mill and forge workers, Logtown residents and Revolutionary War soldiers. By nightfall, the murky depths are clothed in silence, intermittently disturbed by the chatter of night creatures and the voice of the Passaic River. It is not uncommon to see deer, fox and other wildlife moving through these woods, but throughout the years there are other visions that have been reported as well—sightings that are not so easily explained.

Reports have long been made about a woman in a bonnet, a long, white, full skirt and carrying a lantern or a bucket along the route of this old road. Passing slowly through the woods, she has been seen by various people, only to disappear behind trees, leaving behind no trace of her presence. Who could this wandering apparition be? Perhaps it might be more accurate to ask who she might have been.

She has been called the Walking Woman, the Angel of Mercy of Old Forge Road and the Camp Follower Woman. Many people believe her to be the ghost of a resident who once carried water or food along the route, perhaps assisting the Revolutionary War soldiers who struggled to survive the harsh winter when they camped in the area. Another suggestion is that she is related to one of soldiers from the 1779–1780 encampment, a time when wives and other female relatives would follow their men from site to site. Others suggest she was a resident worker whose spirit still performs the chores she did in life. Whoever or whatever this apparition is, she has been seen since the late 1700s and never wanders very far from the route of the all but forgotten Forge Road.

The Wounded Soldier

Just across the street from where Forge Road used to meet Hardscrabble Road is another thoroughfare that climbs the hill surrounding the Logtown area. Old Army Road, as the name suggests, was the route once used by Washington's

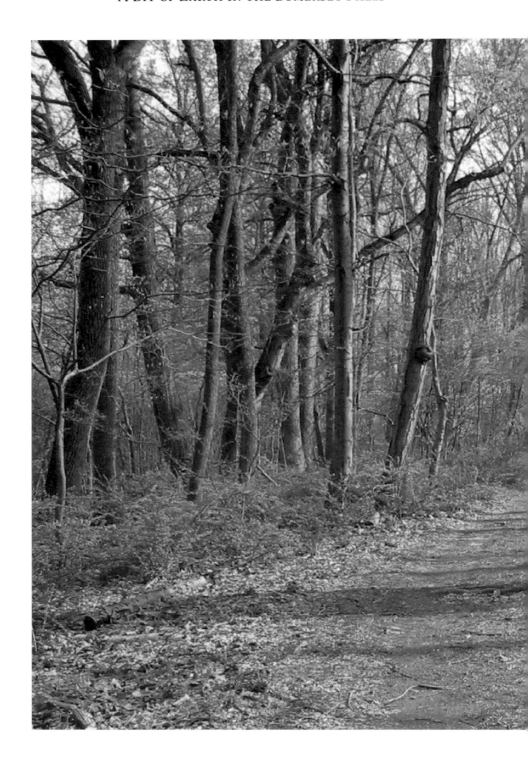

troops to travel between their Jockey Hollow encampment and the Vealtown Tavern in what is now Bernardsville. Climbing up a steep slope through mature woods and snaking around a hairpin turn, one can look down on the bucolic valley that used to be busy with soldiers, millers, farmers and sheep.

From time to time, drivers at night have reported seeing the alarming sight of a wounded young man in their headlights. He appears to be quite real and is described as a young man with light brown hair, tan pants and boots and very similar in appearance to a soldier from the Revolutionary War. Looking to be in excruciating pain, he crawls along the roadside while clutching his side where his white shirt appears to be covered in blood. Seen on this road and at some other places in the vicinity, this apparition simply vanishes in front of the viewers' eyes, but he looks so real that some people have called an ambulance, thinking that the young man had been involved in an automobile accident. Of course, when investigated, there is never any remaining trace to be found of his presence.

The Hovering Mist

Drivers on their way to Mendham have reported another interesting anomaly that is difficult to explain. The firsthand account that I heard was told to me by a local couple who had been on their way home from visiting with friends in Bernardsville. It was a warm, spring night and approaching 11:00 p.m. The husband, with his wife in the front passenger seat, was driving their SUV along a route they had taken hundreds of times along Hardscrabble Road, and one they knew extremely well. Rounding a bend in the road, the lights of their SUV suddenly caught something in its beams. The wife described it as a globular ball of mist or fog with a diameter of three feet that was positioned approximately three to four feet above the road and hovering in place. It also seemed to be pulsing in an irregular manner and changing shape, but did not resemble anything recognizable. Driving at a speed of perhaps thirty miles per hour, there was not time enough to stop, only apply the brakes, but it wasn't in time to avoid this strange, floating form.

The couple was most shaken by what happened next. Instead of passing around the vehicle the way fog normally would, this apparition entered their SUV! The wife described how the mist remained in place as they drove into it, and she witnessed it pass through the windshield, through and around her husband and exit out the rear end of their vehicle. The husband described an icy chill coupled with a jolt of intense melancholy that enveloped his body as he passed through the form, and then it dissipated as quickly as it had begun.

After coming to a stop, the couple exited their vehicle and looked behind them but saw nothing. Neither the husband nor the wife could see or hear anything on the road or off to the side. In fact, there was no evidence to suggest that anything had ever been on the road at all, and they were left in silence with only a warm breeze caressing them in the darkness. Shaken by their experience, and provided with no explanation for what had occurred, they drove home wondering exactly what it was they had encountered.

Interestingly, there is a second couple who told me about an almost identical experience that they had, but it was on Pleasant Valley Road in Mendham, New Jersey. The sites of these two occurrences are two and a half miles apart.

TONGUES OF FLAME

Most of the stories I've included to this point have had ghostly overtones, but there is one tale from the area that, while strange and mysterious, may have its roots in natural science. The story is also set in my godparents' former home.

On one summer afternoon in the late 1970s, Betty was home alone during a particularly violent electrical storm. Frequent lightning and powerful rounds of thunder exploded in the dark, gray sky over the Somersetin area. At the height of this storm, Betty was about to walk up the few stairs into her living room when she saw something that stopped her abruptly in her tracks with her eyes riveted on the floor. There, on her wool rug in the living room, were many tongues of fire, popping, sparking and flaming just above the surface of the rug. They were small, and each lasted only a second as they danced before her eyes. After about thirty seconds the entire phenomenon stopped, and Betty was amazed to find that her rug had not been damaged in the slightest degree by the event.

Eager to tell her husband, she did so the moment he arrived home from work. Bill was amazed to hear the story, and being a scientist, he came up with a possible explanation. His theory is that the phenomenon was caused by highly charged, ionized oxygen that, induced by the electrical storm, created plasma on the vertical, woolen rug fibers that acted like thousands of little lightning rods. This plasma or ball lightning is very rare in nature, but it has been created in the laboratory. Indeed, whatever its cause may have been, Betty was extremely fortunate to witness such a very unique event.

9

The Residual Heart

...And with joy that is almost pain
My heart goes back to wander there,
And among the dreams of the days that were
I find my lost youth again...

—Henry Wadsworth Longfellow, "My Lost Youth"

On occasion, I find time to go back to Lloyd Road and gaze at the area where I was raised. Somersetin has seen numerous changes, as most places have over the years. The feeling is bittersweet, but I am thankful for the experiences and the memories. Surely, the air still pulsates and beckons to be rediscovered, but this time by new and other eyes—those who wish to see more than what lies at their doorstep, those individuals able to see with their eyes as well as with their mind and heart.

This area, like all others, can speak to your very soul if you take the time and have the patience to look and listen closely. This book is a preservationist's *raison d'être*, a foundation from which to motivate everyone to realize that they are a part of something unique. You can enrich your life and heritage, and your primary tools are your curiosity, computer, pen and paper. The stories in this book are recounted to inspire you, the reader, and send you on a quest—a quest for your distinct link to this world. I strongly urge all of you who have set eyes on these pages to explore the world around your home, fortify your roots in the unique history that was created in your piece of the world, record and value the events of your life as a part of that account and share your knowledge and experiences with those who come after you. Reclaim your sense of place that the current pace of this world tends to trivialize and overlook so easily. The quest is a singularly awesome journey, a precious responsibility and a truly enlightening experience that you and many others will treasure forever.

Left: Gordon's Lane.

Below: The author's son, Cory, in Somersetin.

The Residual Heart

Should you find yourself inspired by this book, and should you find yourself revisiting your past or your childhood, you may come face to face with a dear friend, one you may have thought was lost, for you may find yourself gazing into your own countenance as a child. In moments like these, I encourage you to embrace him or her and be as a child once more, if only for a few moments, for this meeting holds the key to the secret of youth. Time passes by us more quickly as adults because we do not live moment to moment, and we lose the ability to see the wonder in the world as it unfolds around us. As we age, we are inclined to leave behind childish ways and increasingly move on to more mature, repetitive patterns of life, and in the transition, many of us lose sight of the magic, lose touch with the amazing and forget the dreams that once filled our days with awe and discovery. The secret I mentioned lies in continually infusing those glorious moments of our past into our lives as adults. When was the last time you rolled down a hill, caught a butterfly, watched the clouds, daydreamed, swung on a swing, skipped a stone across the surface of a pond, went for a walk with no particular destination in mind, or literally stopped to smell some flowers instead of taking them for granted? Knowing that we all have different limitations, you will have to decide what activity is appropriate for your individual situation, but there are many options that beckon. Take some time. Go and be like a child—*today*. Encounter the child you once were. Reacquaint yourself with your youth. Blend the marvel of childhood with the eye of age. Give yourself permission to resurrect and preserve your childhood experiences, and they will, in turn, revitalize your remaining days beyond your expectations.

As I continue on with my life, it is unknown whether I shall ever find a place as inviting, comforting, mysterious and captivating as Somersetin. However, I can say with all certainty that I shall never completely leave, for the area has left a mark on me and I on it. There will always be a piece of my spirit residing on these acres: a little boy pulling a sled up a snow-crusted hillside on a frigid winter's day, a young adventurer playing pirate and climbing trees on a summer evening, a best friend playing in the yards, a little explorer walking in the woods and covering ground touched by millionaires, Revolutionary War troops and Native Americans. There will always be this little boy aware of his surroundings and adding his little piece of history to this bit of earth.

About the Author

Gordon Thomas Ward is a writer, presenter and educator. Born in Tacoma, Washington, his family moved to New Jersey when he was eleven months old. Both of his parents were talented artists and enjoyed the outdoors, and his family divided their time between the family's home in Bernardsville, New Jersey, and a summer cottage in Maine. After high school, Mr. Ward went on to major in fine arts and psychology at Fairleigh Dickinson University in Madison, New Jersey, where his father was a professor. Gordon has worked as a history teacher in the classroom, a youth minister and as a group transformation facilitator in the experiential education field where he designed and facilitated teambuilding programs for twenty-two years. Clients have ranged from education groups in international conference settings to major corporations, government groups, athletic teams, community groups and individuals.

A lifelong writer, Mr. Ward's works have included books, speeches, newspaper and magazine articles and poetry. He is the author of *Life on the Shoulder: Rediscovery and Inspiration along the Lewis and Clark Trail* (Lucky Press, 2005) and a self-published book of original poetry entitled *Windows*. Mr. Ward is currently working on a series of children's books and a manuscript that is more spiritual in nature and explores accounts of how God and angels are present and at work in our everyday lives.

Mr. Ward is also a featured lecturer, speaking about his books and other topics at museums, libraries, colleges, schools and community groups. His presentations are accompanied by projected photos and include titles that correspond to his books, along with others such as "God and Angels on the Lewis and Clark Trail" and "Ghosts at Our Doorsteps."

The author currently resides in Bedminster, New Jersey, where he loves being a father to his daughter and son, and continually pursues his other passions for songwriting and running. Additional information on Mr. Ward's books and his presentations can be found on his website: www.gtwservices.com.

Please visit us at
www.historypress.net